Mad Men,
Death and the American Dream

Elisabeth Bronfen

Mad Men,
Death and the American Dream

diaphanes

First edition | ISBN 978-3-03734-550-4

Layout: 2edit, Zurich | Printed and bound in Germany

www.diaphanes.com

Contents

The American Dream —

A Game of Confidence

Joyce is right about history being a nightmare—
but it may be the nightmare from which no one can awaken.
People are trapped in history and history is trapped in them.
James Baldwin

In the opening credit sequence of each episode of *Mad Men*, Don Draper (Jon Hamm), drawn as a silhouette, literally loses the ground beneath his feet. He has just entered his office and placed his briefcase on the floor when the drawings on the walls along with the furniture begin to collapse. Suddenly he finds himself in free fall, caught in a long downward descent along the façades of the skyscrapers of New York City's midtown. At first, his falling shape, all black except the crisp white shirt he is wearing underneath his jacket, is mirrored in the enticing advertisement billboards projected onto these glass windows: On the one side of the image, we see a pin-up siren whose low-cut red dress matches both the color of her lipstick and her long fingernails, on the other side a spruced up housewife with pearls in her ears, brightly beaming at us. Once the framing has moved into a long shot, the falling figure, reduced to a tiny visual point, passes along a woman's shapely leg, which is adorned with fish-net stockings and a black lace garter. The heterogeneous series of images projected onto the façades all around Don continue to display an array of insignias of middle class satisfaction: vacation on the beach, a nuclear family assembled on the veranda of their home, the laughing face of a

woman with a cigarette elegantly poised in her hand, a glass of beer. Then our gaze is once more drawn close to our hero, who, in the course of his downward pitch, has begun to turn around. If, during the inceptive phase of his fall, he was facing upwards so that, in this supine position, he could see the billboard images he was passing by, gravity, for a brief moment, seems to draw his head alarmingly toward the avenue below with his feet now closest to the sky.

Then our falling man is, once more, able to stabilize himself, and, having returned to his initial lying position, Don catches glimpses of visual fragments that can all be subsumed under the advertisement slogan we see on one of the billboards depicting yet another beach scene: "Enjoy the best America has to offer." The consumer objects displayed on the other billboards further indicate his desires—barely clad seductresses, Old Taylor Bourbon and two hands wearing rings that attest to the fact that marriage vows have been declared. As Don floats by these images, he endows them with life so that, for a brief moment, advertisement posters transform into animated cartoons. Waves of golden whiskey ripple in the glass, the diamond on the finger of the bride begins to sparkle and another alluring woman's outstretched leg almost catches the falling man as he glides past the tip of her toe. But instead, Don Draper persistently continues to drop downwards toward the pavement of Madison Avenue, surrounded by further images which, as a visual sequence, prefigure the irresolvable conflict at the heart of all his endeavors. We see yet another seductive woman juxtaposed with yet another portrait of a happy nuclear family, a single woman looking forlornly out at us, a couple embracing

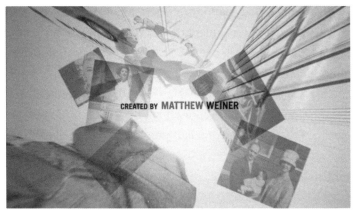

Retrieved and reconstructed images in *Mad Men*'s credit sequence.

and luxury cars prominently put on display. Then the framing once more changes and, for the first time, our gaze is aligned with that of the falling man. What we find at the center of the image, superimposed onto the light background toward which Don's silhouette is inevitably rushing, is the title "Created by Matthew Weiner."

The name of the man who serves as the conceptual focal point of this quality TV show, is, in turn, surrounded not only by the glass façades along which our gaze continues to drop towards the bottom of the buildings, but also by the image repertoire to which the advertisement posters, projected onto these glass windows, make reference. At the top we see the drawing of a redheaded bathing beauty, flanked on her left side by vacation snapshots in color, all three of which could be film stills from *Mad Men*. On the right, Weiner's name is encircled by a vintage black and white photograph of a bride and groom in their wedding car along with a Polaroid of a father standing next to his

wife, proudly displaying to the camera the infant he is holding in his arms. Thus, it is precisely when the name of the creator of *Mad Men* appears in the title sequence, with a set of images quite literally surrounding the letters of his name, that depth and surface of the image converge so as to link together three different possibilities of representing the pursuit of happiness on which the American dream is predicated. Personal memory images and a fictional reconstruction of the past are entangled with commercial drawings that encapsulate scenes of the very satisfaction Don Draper (along with his clients) are meant to strive for. As such, this array of images offers a self-reflexive commentary on the narrative logic of seriality. What will be enacted in each of the episodes following this credit sequence is precisely such a reassembling of retrieved and empathetically re-constructed images within an overarching narrative sustained over seven seasons, whose storyline slowly unfolds the birth of a new generation (namely that of the creator of the series) out of the realized fantasies of its parents.

If this is the first time that we are allowed to witness Don Draper's fall through his own eyes, the reverse shot also shows us this American dreamer for the first time completely from the front. Disclosed is the silhouette of his face while the white shirt offers a prominent contrast to the otherwise black figure. The glass façades, adorned with further advertisement images, now tower above him while he rushes directly past us viewers, only to land again on solid ground. The next image we get of him is the show's iconic representation of Don Draper with his back to us, sitting in an armchair, calm and composed, a cigarette in his right hand and in front of him a grayish white screen completely

wiped clean of any visual traces, except of course the title of the show. He has turned his back on all the images, created or appropriated, that encapsulate the life he has left behind. His horizon is once again fully open. Only in the pilot of this TV series do we get a further title, explaining that 'Mad Men' was a term that the advertising executives of Madison Avenue coined for themselves in the late 1950s—in reference to the location where they were designing images and stories for the dreams of the nation, but also, perhaps, as an indication of their attitude toward their work. They were the superstars of their times.[1]

We can readily read the credit sequence as a condensed vignette of the conceptual visual design on which the entire TV series thrives. What Matthew Weiner takes from Pop Art with this computer animated sequence of images is the conviction that our access to the world is inevitably predicated on the representations that mass culture offers us of a world that has become wholly imbued with commercial value, indeed become a commodity in its own right. At the same time, in the course of their recycling within an aesthetic context, objects from everyday consumer culture become defamiliarized and thus assume a significant surplus value. As such, they draw our attention to the fact that what we are dealing with are artificially produced fantasies referring to real desires and anxieties. Andy Warhol's serial paintings of Coca-Cola bottles, for example, offer a particularly pointed instance of the imaginary negotiation and management of real living conditions. In these paintings, the sheer abundance of the bottles (both empty and in various stages of being filled), lined up in rows that cover the entire canvas, debunk the 'American way of life' for which, by 1962,

they had already taken on an iconic status, even as the fantasies connected with the Coca-Cola brand are promoted, albeit with an ironic twist.[2] One of the most important characteristics of Warhol's understanding of Pop Art is, after all, that art should engage with surfaces (most notably the surface of consumer products) precisely because, owing to their ubiquitous presence in everyday culture, they have become invisible. In other words, an object like the Coca-Cola bottle encapsulates the desires that constitute us as mass subjects, given that, by buying it, we buy into the logic of capitalist consumption.

By depicting the Coca-Cola bottle both as a serial representation within a painting and as a series of paintings, Warhol not only makes this consumer product visible *again*, but also draws our attention to the way we are the effect of the mass media we consume along with the actual drink contained in the bottle. Our conception of ourselves is predicated on the image world produced and brought into circulation by the culture of advertisement. If, then, Don Draper initially has his face turned towards a multiple set of the very billboards he helped create, it is as though, during his free fall, he, too, were confronting a past that touches him emotionally (as will be discussed further on in relation to his pitch for the Kodak Carousel) only once it has been rendered as a series of commercially designed images. At the same time, he can also only grasp this past with the help of these surface representations; much as we, too, can have access to the world of the 1960s only through an imaginary historical re-imagination of it. Significant, however, is that his confrontation with the past not only involves fragmented image details or open image series, but rather that Don can also not

tarry with the images that flash by him. These fragments cannot be assembled into a composite, overarching picture, because gravity is inexorably drawing him into the very future in which he will ultimately land, sitting serenely in an armchair, smoking his cigarette. It is this pull that we call the American dream.

At issue, thus, is not redemption from the consumer images that determine Don and his world, but rather a new beginning after the old world has fallen apart. The turning of the silhouette, which demonstrates Don's abandoning of the consumer images encapsulating his past (as though it were a somatic enactment of the narrative principle of *peripeteia*), is as decisive for the denouement of his story as it is for our involvement in it. After all, the historical re-imagination, for which we, too, yearn nostalgically, has dissipated along with these images. At the very moment when the black figure falls through the vintage snap shots, rushing towards the empty surface at the vanishing point of the image, the loss of world seems complete. Then the grayish white ground is propped up and becomes a screen, facing Don's silhouette, such that he can now contemplate it in tranquility. The collapse of one world emerges as the precondition for the recovery of another world, which is to say for a new beginning. If the gaze of our hero is now directed at a horizon that is once again open, the silhouette, whose spiraling fall is placed at the beginning of each episode of *Mad Men*'s seven seasons, performs 92 times the very trajectory that defines the American project. In that, each time, Don Draper *again* lands in his armchair, only to face an open future, Jon Hamm's portrayal of a charismatic creative director in the Madison Avenue advertisement business serves as the serial personification of

the American project as an ineluctable process of self-transformation and self-recovery.[3]

Each of the episodes that follow this credit sequence revives and thus retrieves a past from which America has moved on by translating the images along which Don's silhouette has fallen into personalized stories located in concrete scenes: family life in the suburban home with Betty (January Jones), which Don will finally leave at the end of the third season; a further attempt at marriage with Megan (Jessica Paré) in the upper East Side penthouse, which he will sell in the seventh season; and, in between, several visits to Anna Draper (Melinda Page Hamilton) on the West Coast, recalling the life he gave up to become a successful advertising executive on Madison Avenue. Furthermore, as part of its elaborate network of intertextual references, *Mad Men* also retrieves memorable paraphernalia of our cultural imaginary to support this entanglement between personal and collective memory work. Fashion, architecture and design of the 1960s have been meticulously restored or recreated, while the popular music of the time is deployed to dramaturgically underscore key plot developments even while also functioning as a pointed commentary on this historical re-enactment. Short sequences from movies and television are either inserted directly into the story (when characters sit in movie theaters or in front of their TV sets), or they appear in the form of cinematic references that characters cite so as to invoke the media images they use to orient themselves in this changing world. In a similar vein, we are also repeatedly shown characters reading books that further encapsulate the *zeitgeist* of the 1960s.

However, as in every historical re-imagination, at work in this cinematically mediated return *to* the past, staging as it does the illusion of a return *of* the past, is a rhetorical double voicing.[4] The dispersed references to the actual political events of the time, which are also interpolated into the fictional re-enactment by virtue of newspaper coverage as well as news broadcasts on the radio and on TV, set up a precise historical frame for the show, beginning with J. F. Kennedy's election victory at the end of the first season and ending with the moon landing in the middle of the last season. However, as these images of the past return to us, we read them through the lens of our current cultural concerns. Indeed, as Weiner himself has confessed, while he initially conceived of this show as "a scathing analysis of what happened to the United States" during the late '50s and early '60s, "the more I got into Don, the more I realized this is an amazing place. Something really did change in those years." Thus, even while Weiner invites us to join him in his time travel to this historical location in the past, this journey is overshadowed by the fundamental change that occurred there. In the same interview with Fred Kaplan, he adds, "I'm interested in how people respond to change. Are they excited by the change, or are they terrified that they'll lose everything that they know? Do people recognize that change is going on? That's what the show's about."[5]

My claim, therefore, is that *Mad Men* is not to be conceived in terms of a reconstructed time capsule, containing a panoply of typical objects and visual formulas that were assembled so that at a future point in time (namely our contemporary moment) inferences could be made about a past era. Instead, the show's

overarching question regarding how American culture reacts to changes that cannot *not* be acknowledged, first and foremost captures, as Frank Rich puts it, "the pulse of our moment." The charm that emanates from Weiner's time travel does not speak to our nostalgia for an America that, owing to its rampant sexism and racism we, in any case, would only want to bring back in the form of highly stylized, recycled visual fragments. Rather, as Rich explains, "it's our identification with an America that, for all its serious differences with ours, shares our growing anxiety about the prospect of cataclysmic change." *Mad Men*, he proposes, "is about the dawn of a new era, and we, too, are at such a dawn. And we are uncertain and worried about what comes next."[6]

The wager of any cinematic time travel is, of course, predicated on the advance knowledge of the viewers. We already know the outcome of the historical events that are brought to life *again* on screen. We inevitably look back at the past world through the lens of the consequences that we know to have been the result of this bygone era. If, then, Matthew Weiner understands his show to be, first and foremost, an exploration of how people respond to changes that are unavoidable, his decision to locate this cultural malaise in the 1960s has a very particular resonance. The vertiginous collapse of the ordinary world that overtakes Don Draper and, over the span of seven seasons, repeatedly compels him to lose the ground beneath his feet, begins in the first season with the cultural change that was decisive for the postwar period, namely the quiet loss of self-confidence and a growing disorientation of precisely the social class to which his Republican-oriented advertisement agency

belongs. As such, the first season of *Mad Men* offers us the portrait of an anxious nation whose confidence, as Michael Wood puts it, "was cracking but still substantial, going but not gone."[7] In the course of the show, however, the sense of bewilderment and unease regarding an imminent transition also pertains to the disintegration of national confidence in the face of military defeat in Vietnam and, concomitant with it, as Weiner suggests, "the idea that the revolution failed in some way and it's time to deal with what you can control, which is yourself, this turning inward."[8]

To look back, today, at the 1960s as the epoch of multiple transitions from which our contemporary culture has emerged, immediately brings similarities into focus. We can readily detect an intriguing parallel between the narrow election victory Kennedy won over Nixon in 1960 and the one George W. Bush achieved over Al Gore in the year 2000. In a similar vein, we can take note of an analogy between the ominous bond between advertisement campaigns and political strategy that began in the 1960s, and the focus groups, pollsters and spin doctors so prevalent in our current political culture. Yet *Mad Men*'s looking back at this past era above all feeds on the recognition that the problems that became virulent then have remained unresolved and continue to have their hold on us today. At issue, in other words, is a conversation *with* the past as well as a conversation coming *out of* the past, rendering visible the cultural survival of this unease. It may well be that there can be no awakening from the force of constant transformation that defines the American project at its core. Weiner's time travel into the 1960s, in turn, draws our attention not only to the extent to which this

lost place continues to haunt us, but also to the fact that the changes that occurred then have decisively shaped the attitudes with which we respond to our contemporary world. With this doubly aligned gaze, *Mad Men* allows us to focus on those cultural fantasies, desires and anxieties that fascinate and trouble us, still, today.

If, then, we conceive of the present time as the continuation and logical consequence of things that were already put into place in the 1960s, Weiner's TV series raises seminal questions regarding how we came to arrive at the point where we find ourselves today. If, furthermore, we read the Don Draper of the credit sequence, whose silhouette keeps falling down along the glass façade of Madison Avenue's office buildings at the onset of each episode, as the classic archetype of the American hero, compelled to constantly redefine himself, clearly more is at stake than merely his personal fate. As his individual story takes its course, *Mad Men* opens a conceptual space for a conversation *with* and *about* America's cultural imaginary in a very specific manner. The TV series emerges as a stage for a reflection about the audacious (indeed vertiginous) claim to moral perfectibility, which this continual re-invention and transformation of the self not only allows but also demands. Along the lines of what the American philosopher Stanley Cavell has asserted for classic Hollywood cinema, *Mad Men* can be taken as serial philosophical fiction, because it unfolds the space where reflections on the state of the nation both in a particular as well as a collective sense—then and now—can be undertaken.

It is, thus, fruitful to recall that in his essay on Shakespeare's *King Lear*, written in 1968, Cavell offers a pointed discussion

of the fragility of the American claim to perfectibility. "Classic tragedies were always national, so perhaps it is not surprising that nations have become tragic," he writes, only to add that in none of the great modern nations "is tragedy so intertwined with its history and its identity as in America." Taking possession of a new world was, from the beginning, conceived as the fulfillment of the Biblical scriptures. The first settlers disembarked and walked onto the new land as though it were a stage on which the dream promised to them by their prophets regarding the possibility of self-recovery was to become true. America was thus never simply a geographical site, Cavell continues, but, instead, had a mythical beginning: "Before there were France and England, there were France and England; but before there was America, there was no America." If, then, America was discovered, he concludes, "what was discovered was not a place, one among others, but a setting, the backdrop of a destiny."[9] At the same time, as audacious as the thought may have been that by settling this new continent the Puritans thought to achieve a divine mandate, this vision was, from the start, fraught with a sense of uncertainty. If America was founded on the conviction that on this stage the Puritans would find their own destiny played out before their very eyes, this fantasy was one that had to continually be reclaimed and reconfirmed.

The dilemma of continual self-perfectibility, however, resides in the conviction that every present state must not only be measured by the fantastic promise of this historical origin, as well as on the radical hope one had placed in this new land. Rather, the optimism necessary in order to maintain this continual effort of self-evaluation also readily reverts (as will be discussed

in greater detail in the fifth chapter) into the fear that these grandiose possibilities may still fail. A blind trust in the future has, as its toxic underbelly, the premonition that this dream may soon be lost or has, in fact, already been lost.[10] At the same time, the knowledge of the fragility of this national vision also makes for its attraction. Profound doubt and the delight in ever new challenges make up the two opposing forces of this vision, and as such continually balance each other. Precisely because one might lose or has, indeed, already lost everything, one is willing to entertain the wager of a new beginning. Cavell offers a poignant trope for the American project, conceived as a promise in whose fulfillment one must trust even if—or precisely because—its outcome is uncertain. America, as a perfect democracy, is achievable but not yet achieved. And this boldly promising but also infinitely fallible national striving toward perfectibility finds in the American constitution an individual, subjective equivalent in the fact that each subject is not only assured the right to life and liberty but also the right to the pursuit of happiness. The American subject—like the democracy at large, to which each gives (but also must keep negotiating) his or her consent—is allowed to, but also must constantly prove himself and herself anew. Each American subject must justify his or her right to happiness over and over again.[11]

While this inexorable national and personal striving toward transformation may be both exhilarating and terrifying, as the lynchpin of the American dream it demands of those who subscribe to this vision to seize any opportunity wherever it may present itself. The loss of a familiar world must be thought of as a unique possibility for renewal and recovery. Indeed, a crisis

is necessary if one wants to return to and rediscover oneself; the momentary self-fashioning must collapse, in order for one to begin again, to awake to new projects. The claim to self-perfectibility is, thus, predicated on acknowledging a strangeness within oneself, and in tandem with this, a willingness to abandon—if only temporarily—one's ordinary life. After all, one can only recover something one has lost or abandoned, one can only strive to make perfect something one knows to be imperfect. To find oneself at a crossroads may mean choosing a path without knowing what shape the new life it leads to will take, what the new day will bring. Decisive is merely the willingness to be ever on the go, so as to be able to return, over and over again. If it is precisely this fundamental reliance on a future yet to be achieved that also corresponds to the ur-American confidence in life as a series of second chances, this optimism always also contains a grain of self-deception and self-delusion. One places one's trust in an idea of oneself that is yet to be realized, on a fundamental willingness to seize an as yet uncertain opportunity should it arise. At the same time, the possibility of failure that one can never preclude must be screened out the moment one decides to embark on the road to a new self because one's familiar world has come to fall apart.

And so we return one last time to the silhouette of Don Draper at the beginning of each episode of *Mad Men*, who, having recovered the ground beneath his feet, sits serenely upright in his armchair. The mandate given to the American subject to become what, in a best case scenario, one has imagined oneself to be is predicated on a double self-deception. The intoxicating and at the same time ominous demand to repeatedly begin

anew, draws those who place their trust in the American dream into a maelstrom of possibilities. To reinvent oneself according to each new situation one finds oneself in, to accommodate oneself to the incessantly changing conditions of one's world—all this means engaging in a chatoyant illusion. With each new self-fashioning, regardless how necessary or pertinent to one's survival this may be, one leads others to believe something about oneself, and, in the process may, to a degree, even be duping oneself. Pretense is at issue not only because roles that must remain exchangeable can therefore never be completely assumed. Rather, what one is enthralled with is the force of the American dream, not its concrete realization. What one desires is the act of striving, not the goal to be achieved. Once the archetypical American hero has embarked on the path towards perfectibility, has begun his pursuit of happiness, he can continually assure himself that with each new stage of self-realization, he is coming ever closer to achieving a dream, which must, by necessity, always remain open, and thus entail an uncertain horizon of possibilities.

In the credit sequence, however, the issue of dupery is taken to the level of the narration itself, given that at the very moment when Don Draper once again lands in his armchair, we also realize that his fall along digitally generated images (representing his idea of happiness as a sequence of images) emerges as a supreme confidence game. His fall was never really life-threatening. Indeed, it is worth recalling that, as a classic American *topos* and an aesthetic attitude, the con game plays with—even as it undermines—the very meaning of reliance and certainty that is contained in the word 'confidence.' This trickery skill-

fully deploys self-reliance as a stratagem, banks on the other's willingness to trust even while rendering uncertain the confidence it has garnered, revealing trust itself to be untrustworthy. At issue in this artful ruse of deception, however, is not only the ability to play with and, indeed more likely than not, betray the other's trust, but also the fact that an opportunity to do so has suddenly, and often unexpectedly, opened up. Thus, even as a confidence man willfully pretends to be something he is not, promises something he cannot deliver, he reveals both his own power of seduction and his perfect sense of timing. The con artist can only dupe others, can only convince them of something or successfully pitch something to them because he has won their confidence at exactly the right place and the right time. Treating the idea of the confidence game as a literary *topos* that *reflects* the concerns of the American project even as it *reflects on* the aesthetic attitude of serial representation, the following discussion of *Mad Men* will take as its focal point the archetypical American con artist Don Draper. As the credit sequence puts on display over and again, it is over his body (and the vicissitudes of his fortune) that the question, so decisive for the show, regarding the meaning of personal, national and aesthetic transformation, is given shape, negotiated and resolved in the course of seven seasons.[12]

Pitching America

The show is about using advertisement to talk about the human condition, it's always used metaphorically as an expression of what is going on with the characters.

Matthew Weiner

Mad Men begins with a quandary regarding an advertisement pitch. In the opening scene of the pilot, "Smoke Gets in Your Eyes," we find Don Draper sitting in the Lenox Lounge Bar, desperately composing slogans for Lucky Strike on the paper napkins that came with his Old Fashioned. Because the government has told the tobacco industry that it is no longer allowed to advertise that cigarette smoking is safe, his advertisement agency, Sterling Cooper, is compelled to change their strategy. Yet our creative director, Don Draper, is unable to come up with any catchy ideas that might remedy the unexpected situation they suddenly find themselves in. The next day, the psychologist Dr. Greta Guttman (Gordana Rashovich), who studied psychoanalysis in Vienna before the war, offers a bold suggestion concerning the hazards of smoking. Proudly she hands Don the research report that the agency has asked her to compile. So as to turn the government's interdiction to their advantage, she suggests bringing the death wish inherent to all cultures into play; a drive, as she notes, of which Freud postulated that it was "as powerful as those for sexual reproduction and physical sustenance" (MM 1.1).[13] Indeed, openly acknowledging the danger the public has begun to associate with smoking

could be seen as an assertion of the very independence so fundamentally at the heart of the American way of life. Don resolutely rejects her suggestion, explaining that it would not make convincing copy on a billboard. To signal that he wants to hear no more about what he considers to be a perverse approach to their problem, he throws her report into the trash. Yet lacking any alternative ideas, he finds himself sitting in the conference room, where the owners of the Lucky Strike corporation have just arrived, with a folder containing only empty sheets.

The tobacco people, nonplussed by the government's annoying interference in their business, which Lee Garner Jr. (Darren Pettie) directly compares to censorship in communist Russia, are completely open in admitting that manipulation of the mass media is what they are paying this agency for. With both Reader's Digest and the Federal Trade Commission publishing reports that proclaim cigarettes to be linked to certain fatal diseases, they need a new image that will turn public opinion in their favor again. If, however, the media power ascribed to the agency, Sterling Cooper, is, thus, from the start, openly conceived as the skillful influencing of others, at issue is not so much a critique of the fact that advertisement is nothing other than the production of illusions. Rather, the point is to draw attention to the analogy between a successful advertisement campaign and the TV series *Mad Men* itself, given that both achieve their desired effect not *although* but precisely *because* they understand themselves to be engaged explicitly in a manipulation of their audience. After all, as spectators of this scene we are as anxious to see what solution Don will come up with in order to resolve his predicament as are his colleagues—namely Roger

Sterling (John Slattery), the senior partner who implicitly trusts the unbeatable imaginary powers of his creative director, und Pete Campbell (Vincent Kartheiser), who, at this point still a junior accounts executive, wants to rise in this agency at all costs.

While Roger once more reminds all those present that "we're no longer allowed to advertise that Lucky Strikes are safe," the room begins to fill with the smoke of their own cigarettes. It is the smoke of dazzlement and infatuation, but also the smoke out of which an imaginary shape—an effective advertisement slogan, a TV series—can emerge. Then, turning to his creative director, Roger adds, "I think maybe that's your cue." The fact that Don stalls his expectant listeners by sheepishly leafing through the empty pages in his leather folder is decisive for the dramaturgic structure of the scene. His hesitation marks a risky moment in the narrative. The astonishing slogan that he will come up with in the course of a pitch that is presented as being part con game part inspiration thrives on the possibility that he might fail at his task. Narrative tension is further enhanced by virtue of the fact that, unsolicited, Pete intervenes in the discussion, allegedly to help Don out of what appears to be an embarrassment. Pete has purloined Dr. Guttman's report and, while Don assumes the pathos gesture of the brooding thinker, brings forward the bold proposition she suggested. He explains to the bemused men sitting in front of him that, given that it is a fairly well-established psychological principle that society has a death wish, there would be great market potential if they found a way to tap into this collective drive. The fact that, in order to deliver his speech, Pete has chosen to stand up and is, thus,

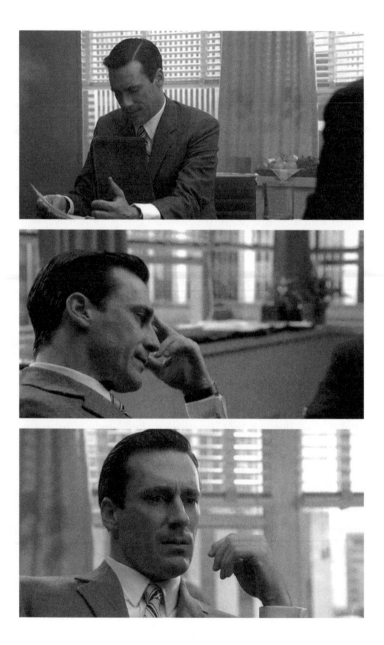

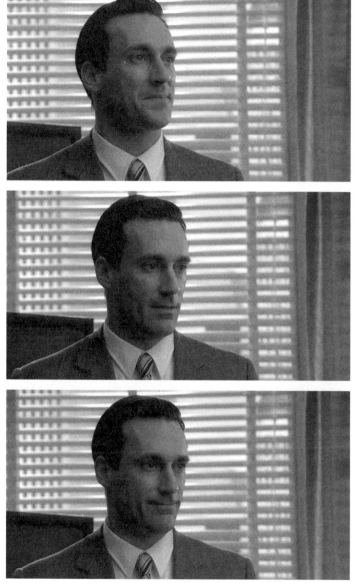

Lucky Strike sales pitch: Pathos gestures of inspiration.

towering above all the other men in the room while he holds forth, is equally significant for the dramaturgic composition of the scene. The rebuff he garners for his preposterous intervention, forcing him to take his seat again in shame, only serves to underscore Don's true genius.

For Lee Garner Sr. (John Cullum), the presupposition of a national death drive is as unthinkable as any acknowledgement that his cigarettes might be dangerous. Retaliating Pete's injury, he furiously asserts: "I'm not selling rifles here. I'm in the tobacco business. We're selling America. The Indians gave it to us, for shit's sake." To be allowed to smoke without restrictions thus stands in for a fundamental American attitude, namely the resistance to any form of governmental regulation. At the same time, the older man implicitly gestures toward the historical origins of the nation: The settling of America predicated on the conquest (which is to say the betrayal and destruction) of its indigenous inhabitants. Don's persistent silence, in turn, threatens to turn this pitch into a fiasco, given that at this point, Lee Garner Jr. encourages his father to break off the conversation and leave the meeting without having arrived at a satisfying solution. Yet precisely at the risky turning point where only a thin line distinguishes victory from defeat, and as such marking the dramatic *peripeteia* of the entire scene, genuine inspiration comes to the man on whose genius everything depends. The sound track picks up Lee Garner Sr.'s reference to the 'Indians' and we begin to hear spectral flutes, as though this music were coming back to us from a far away past. The camera, in turn, slowly moves into a close-up of Don's face, now bathed in white light.

As though he were listening to an inner voice guiding his inspiration, he addresses the tobacco people just as they are about to leave the room. Now, finally, the sales pitch everyone has been waiting for—including us viewers—can actually begin. As Don fervently asserts, given that neither Lucky Strike nor their competitors can make any health claims regarding cigarettes, the Federal Trade Commission and Reader's Digest have actually presented them with an astonishing advertising opportunity: "We have six identical companies making six identical products. We can say anything we want." The stroke of genius on the part of Sterling Cooper's creative director, which will culminate in the slogan "It's toasted," is thus, from the onset, presented as an artful sleight of hand.[14] The decision to focus their new advertisement campaign on how these cigarettes are manufactured is explicitly conceived as a ruse, aimed at drawing attention away from the issue of health risks. As Don asserts, while everybody else's tobacco may be poisonous, Lucky Strike's is toasted.

The sales pitch itself, however, is not over yet, even though Don has now found the perfect tag line. While Lee Jr. may have sat down at the table again, both he and his father require an explanation as to why this particular slogan should be the one to work in their favor. The fact that Don must begin again also allows for a comment to be made on the fascination emanating from the series *Mad Men* itself. It gives Don the opportunity to openly address the imaginary surplus that a successful TV show, much like any effective advertisement campaign, boils down to, especially when what is at issue is selling the American project. Illuminated in the back by a clear, white light, Don looks

ecstatically into the distance, as though he were inspired by an invisible source that corresponds to a deep, intimate insight. "Advertisement is based on one thing: happiness," he explains. "Happiness is the smell of a new car. It's freedom from fear. It's a billboard on the side of the road that screams with reassurance that whatever you're doing, it's okay. You are okay."

If, initially, he is himself taken in by the very feeling of happiness he ascribes to advertisement, by the end of the pitch, he assumes a quiet melancholic pose. The self-assurance, "you are okay," seems like an addendum with which he appeals primarily to himself. Furthermore, if such diverse things such as a new car, one of the four fundamental human rights, and the feeling of security can all be subsumed under one and the same concept, then at issue is a very particular notion of happiness.[15] The satisfaction gained is based on an imaginary overcoming of the sense of lack or fallibility, which, as the flip side of happiness, can never be fully suppressed; namely decay, trepidation and the sense of personal inadequacy. Indeed, Don's conviction that the common denominator of advertisement lies in its ability to elicit happiness itself represents what Sigmund Freud calls a protective fiction (*Schutzdichtung*). The Viennese psychoanalyst coined this term to address the fact that any work of fantasy protects the daydreamer by displacing knowledge he or she does not want to confront directly into a more agreeable story, even while this fiction seals off (*abdichten*) all painful aspects of the unwelcome psychic truth. Beneath the surface of the sense of happiness that is sold along with each package of Lucy Strikes lies a vague knowledge about the fugacity of such satisfaction.

Once Don has finished the second part of his pitch, Lee Garner Sr., repeating the phrase, "It's toasted," finally also sits back down at the table, and, with a benign smile, adds: "I get it." This recognition finally causes a smile to flicker across Don's face, even though this pleasure is strangely contained, as though he were but slowly waking up from the onrush of his own vision. A few moments later, when, in private, Roger tells him that although he had him worried, his presentation was inspired, Don confesses, grinning sheepishly: "For the record, I pulled it out of thin air." What is, thus, introduced with this first sales pitch for Lucky Strike is not only the seminal correspondence between the American project and any successful advertisement strategy ("We're selling America"), to which the show *Mad Men* will continually have recourse. Rather, the scene of inspiration Don puts on display also proves to be so effective precisely because his performance explicitly functions as a con game. Don's swindle not only consists in seizing an opportunity, but also in discovering in the deception on which it is predicated ("We can say anything we like") a truth about its own powerful effect.

As the semantic ambivalence residing in the term 'confidence game' suggests, the con man is self-consciously playing both *to* and *with* the trust he has persuaded others to place in the act he is putting on for them. The notion of happiness that this first sales pitch (as well as the Lucky Strike advertisement campaign that will emerge from it) invokes is, thus, so much more convincing because it banks on a wish to be seduced—on the part of the clients as well as those who buy their cigarettes. Everyone knows that the examples for happiness Don has alluded to are

illusions, divorced from any concrete reference in lived reality. And yet, precisely because they know this to be the case, everyone is willing to be taken in by his game of seduction. At issue is no surreptitious manipulation but rather one that is overt in its intention, its strategy and its effect. Everyone is in the know, including the viewers.

Significantly, Don speaks to the other men about what they, in particular, might do to sell their cigarettes. At the same time, he comes up with a narrative about happiness that encapsulates what the American public in general needs, precisely because he can feel within himself this larger cultural desire. In 1957, which is to say a few years before *Mad Men* sets in, the French semiotician Roland Barthes already compared mass culture with a machine that renders collective desires visible. Myths of everyday culture, Barthes argues, dictate what we should be interested in, as though we would be incapable of finding out what we desire without such external help.[16] With this first pitch, Don is shown to be someone who, in the sense Barthes suggests, is particularly skilled at operating the desire machine that advertisement so blatantly taps into. Matthew Weiner, in turn, discloses in an equally open manner, that we are not only drawn to Don's charismatic charm because he succeeds in winning our confidence, but also because we want to be taken in by his seductive play. Don's own self-confidence, which he will have to prove over and again in the course of the subsequent sales pitches, thrives on the fact that he allows himself to be carried away by the force of his seductive inventions as well. By giving a shape and a name to the fantasies of others, he always also speaks about—and to—himself.

This first sales pitch for Lucky Strike thus contains both a self-reflexive comment on the illusion of mass manipulation *and* an argument for an emotional (indeed mythic) truth that can only be articulated through aesthetic refiguration. Or put another way, it debunks the illusion on which all advertisement is predicated even while holding on to its affective effect. It inaugurates the audacious balancing act between intuition/inspiration and calculation, which all subsequent sales pitches in *Mad Men* will make use of. As marked moments in a continuous series of sales pitches, each of these individual scenes recalls previous examples from the narrative at large (including pitches we see only as flashbacks) even while each individual scene also anticipates further examples still to come. At the same time, in that they speak to a protean desire, they function as narrative nodal points where past and future are knotted together in the present.[17] The slogan "It's toasted" may, on the diegetic level of the show, fit perfectly to the current crisis that has befallen the tobacco industry (even if, regarding actual advertisement history, it is an anachronism), and yet, no single sales pitch is ever final.

This raises the issue of seriality, which here concerns the fact that each advertisement campaign must be repeated because, given that its strategy could always be perfected, it allows for (but also requires) constant innovation. The continual reformulation, in turn, negotiates a current concern (selling Lucky Strikes without bringing up health issues), by invoking emotionally effective images and stories of the past (the memory of a new car, of a billboard on the side of the road), so as to find a solution in and for the future (the role this first pitch scene will

have played in *Mad Men* once the TV show is completed). At the same time, given that everything revolves around a nebulous desire—as ungraspable as smoke—each pitch cannot, but also must not ever be fully satisfied. And it is precisely in this temporal reversibility, picking up on recollections of the past even while being directed resiliently toward the future, that one can also locate the significant analogy between sales pitches in particular and the American project per se. It, too, is achievable but not yet achieved.

There is, however, more at stake in this inaugural pitch scene than simply exposing Don Draper's creativity as a con game. The fact that, when he delivers his inspired speech, white light envelops his face even while he gazes ecstatically into the distance also introduces him as a poet genius in the tradition of the transcendentalist Ralph Waldo Emerson. In other words, with this first pitch scene, Don is installed as the master of an inspired intuition that allows him to capture the spirit of his time and transfer it into poignant slogans, with stirring stories to accompany them. In this scene, however, he also puts on display precisely the self-reliance that Emerson lauds as the expression of genuine American individualism: "To believe your own thought, to believe that what is true for you in your private heart is true for all men,—that is genius. Speak your latent conviction, and it shall be the universal sense; for the inmost in due time becomes the outmost […] A man should learn to detect and watch that gleam of light that flashes across his mind from within […] In every work of genius we recognize our own rejected thoughts: they come back to us with a certain alienated majesty."[18]

Decisive, furthermore, is the fact that Don's ecstatic gaze into the distance exhibits a conversation with himself; it has the status of a marked narrative moment in which he discovers something about himself. If, however, the bright illumination of his figure offers a visual correspondence for this experience of self-recognition, to be complete, this inspiration also requires an externalization of his innermost thoughts. While the images Don evokes (a new car, a billboard) function as his distinctive tropes for personal happiness, they also entail a more general claim for American culture as a whole. And if, in the course of this sales pitch, he assumes various pathos gestures—the pose of the melancholic thinker, of the ecstatic genius, of the awakened visionary—this sequence of poses supports a philosophic argument. The sorrow we read on his face at the beginning and the end of his inspiration serves to disclose that happiness and quiet despair are the two sides to the uniquely American claim to self-perfectibility.[19]

The Lucky Strike sales pitch, furthermore, inaugurates a series of pitches, in which several thematic concerns of the series *Mad Men* come to be condensed in an overarching argument about the vicissitude not only of Don's personal fortunes but also that of the agency, Sterling Cooper, as well. Not only do these scenes of persuasion draw our attention to the way a willingness to consume ever more mass market products invariably involves an unquenchable, indeed intangible desire. Rather, given the competition between those working in the creative department and those working in accounts in all of the advertisement agencies on Madison Avenue in the 1960s, the series of sales pitches that punctuate the narrative of *Mad Men* all

the way through to the final season, bring to the fore the status that creative work takes on in this business in general. At the same time, the sales pitches also function as a barometer for the financial survival of the particular firm the show focuses on. Indeed, the fragile status of Sterling Cooper is always, albeit obliquely, at issue, given that, while pitching a strategy to a client (in order either to keep an account or to acquire a new one), the agency must make a bid for itself over and again as well. Yet these pitch scenes also allow Weiner to reflect on his own medium, which is to say on the quality TV series as a philosophical novel of the early 21st century. Over the course of seven seasons, he, too, must repeatedly appeal to us, his audience, to continue putting our confidence in his time travel. And finally, what is at stake is not only an engagement with the sales strategies for specific consumer goods (to which one might count the series itself), but the American project as such. Lee Garner, Sr. is right to claim that "we're selling America."

What the series of pitch scenes thus also serves to negotiate is how advertisement (along with cinema, TV and news broadcasting) creates visual narratives which not only helped bring political concerns into circulation in the 1960s but that are still resonant today. The ideological power game that these pitches aesthetically refigure enmeshes the authority of the advertising executives to assert their strategies, on the one hand, with, on the other, the desires of their clients (and implicitly those of the consumers in general) to be overwhelmed by a desire machine that always also makes itself recognizable as such. To understand how this complex game with confidences works, it is fruitful to recall that the word 'pitch' refers not only to the act

of persuasion by which an agency obtains an account but also, in fact, joins together a wide array meanings, all of which resonate in the individual pitch scenes we encounter in *Mad Men*.

As a noun, the word 'pitch' refers to a variety of dark, thick sticky substances that can be obtained from the distillation residue of wood or coal tar, and, as such, evokes the color black. With this color, we readily associate the digitally generated black silhouette of Don Draper in the credit sequence, whose fall along the façades of Manhattan skyscrapers functions as the visual continuity of the entire series. Yet pitch as a color also brings into play the decisive role that the African American population plays within the cultural changes that marked the society of 1960s. *Mad Men* traces the slow and admittedly peripheral access of individual African American characters into the Madison Avenue world of advertisement.

As a verb, 'to pitch,' describes various movements that involve throwing, tossing, or discarding something or someone no longer deemed necessary. Thus, each time the show allows a character to drop out of the narrative, it implicitly speaks to the shadow side of a successful sales pitch; which is to say to all those who do not stay on top of the game. Most prominently, however, we associate pitching with baseball, where the ball is carefully aimed from the mound to the batter. In this game, pitching also refers to an adversarial relation between two competing teams, regulated by a set of rules and taking place within a clearly demarcated field. Here, the goal of the pitch, however, is straightforward, much as the pitcher has a clear addressee. He tries to give a particular spin and force to the ball so that his team might win. If, in turn, the batter does

not respond to the way the ball has been pitched, the game cannot be played.

Yet pitching can also involve other movements, equally important for the narrative development of *Mad Men*, like stumbling around, lurching, falling or plunging headlong, as over a railing. As a nautical term, 'pitch' refers to the alternate dip and rise of the bow and stern of a ship as well as the lift or descent of the nose and tail of an airplane. As an architectural concept, it refers to the specific slant at which the angle of a roof is set, to the highest point of a structure such as an arch, as well as to the downward degree of a slope. Pitching thus involves not only a calculated aim and the angle from which something is thrown at a designated person or place. Rather, it also refers to the upward and downward movement of a trajectory, which—applied to the over-arching narrative of this TV series—concerns the emotional and intellectual development of individual characters as much as the fate of the agency, but also of the American nation, for which the agency stands in.

At the same time, 'to pitch' can mean asserting a claim, posing a demand, assigning someone to a particular position. As such, pitches are predicated on aims or assertions that one intends to follow up on. One pitches a tent so as to set up living quarters, one pitches a stake in the ground to signal possession of this piece of land. In the act of pitching, a space is designated as that which one intends to call one's own, a claim is made on a territory one intends to occupy. In conjunction with *Mad Men* one might say that Don Draper and his partners use their successful pitches to continually assert themselves against the other advertisement agencies, claiming, reclaiming or losing

their position on Madison Avenue—and in the public realm at large—by taking over new territory or by being forced to cede what they have already established as their ground. With each sales pitch, they either accrue a new account that allows their influence and importance to grow, or they retain an old client they are in danger of losing. The volatility of these pitches is such, however, that their success is never assured. Failing at a pitch can be both a personal sign of defeat and a mark of the failure of this particular advertisement agency to assert itself.

The unsteady trajectory of the act of pitching, however, also has an emotional component, referring as it does to a level or degree of intensity of an action. Whenever they are creating a new advertisement strategy, Don Draper and his team work at a feverish pitch. If 'to pitch' means setting a specific upward or downward slant, it also means setting something at a particular level, degree or quality of emotional effectivity. Given that successful persuasion involves being perfectly attuned to the needs of one's audience and adapting to their expectations, the success of Draper's advertisement strategies (much as the success of Weiner's TV show) consists in neither overestimating nor underestimating his audience. Don incessantly tries to pitch his presentations in such a way that he gets the tone exactly right. Indeed, a successful sales pitch involves finding a happy balance between innovation and convention. Not to miss one's mark in this case means engaging with the expectations of one's target audience. It means discovering which visual stories the clients (and their customers) are willing to identify with precisely because these are the ones that appeal to their fantasies and, thus, are the stories that will convince them to buy either an idea or

a product. Forceful creativity and the ability to empathize with the desires of one's clients as well as one's target audience thus emerge as two sides of the same coin.

To think of pitching as an act of correctly gauging a mood, however, also brings an acoustic aspect into play. In musical terms, 'pitch,' after all, also refers to the distinctive quality of a note, the grain of a voice, the particular sound of an instrument, the inflection of a statement. And, indeed, the sales pitches in *Mad Men* always also involve a question of tone, of voicing that is both calculable and intangible. Achieving perfect pitch (or failing to do so) while throwing out an idea during a sales pitch can be as decisive as the aim one takes. Don Draper's creative genius consists to a large degree in the fact that, regarding the cultural tone of the 1960s, he can claim to have perfect pitch, even if—as is the case with the Beatles' record *Revolver*—he still needs to get accustomed to a new musical sound.

Thus, while in the world of advertisement (much as in politics and in the television industry), pitching involves first and foremost a line of talk whose aim is to persuade one's clients (and their target audience), the panoply of associations contained in this term resonate in the many pitch scenes we see in *Mad Men* as well. Just as in the Lucky Strike scene, we find aim and tone coming together in subsequent sales pitches, too, notably when Don brings forward his advertising strategy with a particularly energetic and seductive verve. Intensity is further at work in the sense that each sales pitch not only promotes or sells an idea in a high-pressured manner. Over and again, Don and his team pitch their ideas with a distinctive thrust that has taken into account the expectations of their clients even while

self-consciously factoring in the emotional effect they intend to achieve. As in baseball, the sales pitches in *Mad Men* also take place in a clearly delineated playing field. In this case, however, the two groups, usually sitting at opposite sides of the table in a conference room, are not competing teams. Rather, the advertisers vigorously seek the approval of their clients. Each side wants to be convinced by the other, wants to join forces with the other. Each wants to pitch in where mutual interests are concerned. Everyone wants to support the members of their team. In the sense of an argumentative back and forth, the clients may, at certain points, even pitch in themselves, isolating a point ("All tobacco companies have the same problem"), which the advertisers, in turn, can pick up on ("We can say whatever we want"). Of course, a certain degree of aggression remains, given that at any time during the presentation, a member of one side may pitch into someone on the other side (as when Lee Garner Sr. verbally attacks Pete for his suggestions that they bring the notion of a collective death wish into play). Then again, once the advertisers and their clients have pitched on the ideal solution—"It's toasted"—each side can make claim to this mutually beneficial outcome.

The common denominator of all the sales pitches, one might say, is the fact that those who are present in the room are attuned to each other in a mutual play of seduction, undertaken in the name of promoting a particular product (Lucky Strike), but also a national project ("We're selling America"). As a result, the sales pitches in *Mad Men* also speak to the way postwar America, on the level of the cultural imaginary, is produced as an image and through images, which are in constant need

of renegotiation.[20] Matthew Weiner's historical re-imagination of 1960s culture underscores how this period was also a watershed moment regarding the interrelation between image-making, Cold War politics and liberal market economy. At the same time, the pitch scenes in *Mad Men* not only serve to reflect on the affective dimension of any fascination for mass market products, including quality TV itself, but, taken as a series, the sales pitches across the seven seasons of *Mad Men* also reflect on the narrative trajectory of the show as a whole. They serve as a commentary on both Don Draper's charismatic ascent (and the danger of falling that besets him) and the various mergers undertaken by his agency in an attempt to ward off a take-over by McCann Erickson. As will be shown in greater detail below, by bringing home the point that American culture feeds on images of happiness, which those who design and circulate know to be illusions, these sales pitches make both an aesthetic and a political point. Indeed, they function as the marked nodal moments in the overall narrative of the show, where, as part of America's engagement in the Cold War, the deployment of consumer products as weapons in a global cultural battle come to be enmeshed with postmodern aesthetics.

It is, thus, only logical that if the inspired pitch for Lucky Strike (selling the spirit of American resilience) serves as the acme of the first episode of *Mad Men*, the final episode of this first season should culminate in a further stroke of genius on the part of Don, albeit one which he meticulously plans in advance. His pitch for the Kodak Carousel is so successful that, within minutes of its completion, it becomes the legendary signature of his creative brilliance; the crowning achievement he

will never surpass, and thus the perfect sales pitch by which all the subsequent ones come to be measured. This performance establishes Don Draper as the absolute sovereign on the creative side of Sterling Cooper, even as his personal achievement also reinforces the fact that, at the end of the first season of *Mad Men*, this small agency is still financially stable. At the same time, the unequivocal power attributed to Don's supreme con game in this particularly impressive sales pitch also underscores the recovered confidence of an American public that had just elected John F. Kennedy as the 35th President of the United States.[21]

At the onset of his presentation to the two representatives from the Eastman Kodak Company, Don explains that while the most important concern of advertising consists in arousing an itch for the new, there are exceptions to this rule. In the rare occasion, he goes on to explain, when the target audience has a deeper, sentimental bond with the product, one can tap into the wistful affection for the past known as nostalgia. Once the secretary, sitting behind him, has turned off the overhead lights, he turns on the Kodak slide projector. The next shot shows us the assembled group, gazing at the still empty screen while directly facing us. Refracted on the lens of the camera that is filming the scene, the bright light, streaming into the darkened room through the electric bulb behind the lens of the slide projector, has produced several red circles. For a few moments, all those sitting in the conference room, reverently waiting for the presentation to begin, as well as Don himself, standing behind the slide projector, are encircled by the biggest of these red halos, as though, for the duration of the pitch, they were all enclosed

in this protective bubble. For the sentimental time travel that sets in with the first slide (along with the eerily yearning melody on the soundtrack), Don has shamelessly plundered the archive of his personal family snapshots. Images of his children, having fun on a playground, as well as of himself and his wife, Betty, enjoying an outing, have been skillfully re-arranged into a visual sequence to draw everyone into their magic. By using these slides to evoke his personal memories, Don has found a way to trigger nostalgia's delicate potency for his audience as well.

Don does not need to trust in the luck of spontaneous inspiration because, this time, the story he proposes to sell to his clients is one he has carefully concocted in advance. In Greek, he explains, "nostalgia literally means the pain from an old wound. It's a twinge in your heart far more powerful than memory alone" (MM 1.13). The Kodak slide projector, he emphatically asserts, is not a space ship but rather a time machine.[22] At the very moment he utters this programmatic description, a snapshot of Betty Draper, pregnant, appears on the screen. She is sitting on the sofa in their living room, her face beaming with joy, while Don has placed his head lovingly on her round belly, resting it there as though he were looking for comfort and protection on this maternal cushion. Don's definition of the word 'nostalgia,' is, of course, imprecise. The correct etymology of the word comes from 'return home' (*nostos*) and 'pain' (*algos*). As such, it alludes to a desire (or request) to return to a home endowed with personal associations of happiness, which, as Svetlana Boym has argued, either no longer exists or perhaps never existed in the form in which it is belatedly re-invoked.[23] Yet Don's reference to the pain of an old wound that will not

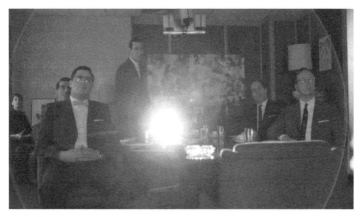
Kodak Carousel sales pitch: Enveloped in a circle of light.

heal is pitch-perfect regarding the affect he seeks to elicit with his presentation. After all, at issue in his sales pitch is the claim that only this Kodak slide projector can engender a series of moving images whose emotional force exceeds and transcends conventional memory work. Not only do the slides he projects on the screen allow the past to flash up again in the present, but what is at stake is nothing less than the possibility of interrupting the ordinary flow of time. Because he has control over the sequencing of these snapshots, Don can demonstrate how this particular slide projector also makes it possible to jump backwards and forwards in the past one is returning to; how it allows one to reassemble images, laden with powerful emotions, in such a way as to uncover clandestine connections.

The Kodak Carousel thus emerges as a desire machine of a very special kind. The lost place of security we ache to go back to again is one we become conscious of only with the help of a series of images that affect us primarily (and perhaps only) in

the present. The newly rearranged images serve as evidence that this place of happiness once existed. The advertisement slogan that Don seeks to pitch to his clients works by virtue of comparing the round tray, into which the slides have been circularly placed, with the amusement park carousel they implicitly associate with their own childhood. His wager is that, moved by the magic of a reversible sequence of images from the past, adults can tap into their own fantasies and, traveling like a child, find themselves circling in their own nostalgia: "Around and around and back home again" (MM 1.13). While this final part of the sentimental story he has to tell is accompanied by further snapshots of his children playing, the acme is introduced by yet another image of the maternal body of his wife. Just before he makes his final point, namely that the home we return to while partaking of a visual revisitation of the past is "a place where we know we are loved," he pauses to show a photograph of Betty, sitting on a sofa, holding an infant in her arms. In this snapshot, Don has placed his left arm around her and is looking at their child, while she looks out at the camera. The promotion poster he has designed, is, in turn, sandwiched in between two final snapshots. In the first, Don is holding Betty, dressed in her wedding gown, in his arms, and in the second, the elegantly dressed couple is kissing.

Himself enthralled by these last three images of marital happiness, Don seems not only to be captivated by his own presentation, but also to have understood something because of it. In contrast to the reticent smile at the end of the Lucky Strike pitch, this time quiet joy lingers on his face even after he has finished speaking. What remains undecided, however, is whether

Don has fallen prey to his own manipulation. Has the sequence of images he composed for this sales pitch allowed him to recognize his yearning for the family life from which he is already shown to be fleeing throughout the first season? Or is he simply pleased with the overwhelming effect his presentation has had on his audience? In either case, what this pitch discloses is the fact that, if this series of images seeks to engender the idea of a felicitous place one yearns to return to, this is a purely virtual site. It is so potent, to boot, precisely because this delicate illusion can emerge on screen only for a short period of time. Its affective value is contingent on transience, of which Freud astutely notes: "Transience value is scarcity value in time. Limitation in the possibility of an enjoyment raises the value of the enjoyment."[24]

Don's presentation is also so powerful, however, because his pitch implicitly draws on knowledge regarding a gap in the very happiness that the memory images projected on the screen celebrate. It is, thus, fruitful to recall Freud's other claim: "A happy person never phantasies, only an unsatisfied one." While each single fantasy serves as "the fulfillment of a wish, a correction of unsatisfying reality," most often, the dreamer tends to replace ordinary unhappiness with what he believes to have possessed in his allegedly happy childhood, namely "the protecting house, the loving parents and the first objects of his affectionate feelings."[25] In other words, the work of fantasy is itself predicated on jumping backwards and forwards in time. It seeks to replace current discontent with memory images of the past that are themselves already conceived as a correction of the past; it is predicated on the overvaluation characteristic

of a child's imaginary capacities. If, then, Don's slide show returns twice to Betty's maternal body, this foregrounds a double displacement that does more than merely compensate for his current despair. Overshadowing his pregnant wife, there is the ghost of his own mother, who lost her life giving birth to him. The twinge in the heart that Don ascribes to the delicate potency emanating from his nostalgic image sequence thus involves the ordinary unhappiness that compels him to strive for an improvement of his life.[26] However, it also concerns the knowledge of personal mortality that comes to be negotiated at the maternal body precisely because the life which the mother gives to her child is invariably a finite one, with the navel serving as the somatic mark of this two-sided gift.

It is, perhaps, no coincidence that Don's idiosyncratic definition of nostalgia recalls Roland Barthes' notion of the *punctum*, a detail that, according to the French semiotician, shoots out from a photograph and wounds each spectator respectively, though always in a way particular to him or her. Indeed, the claim Barthes makes in his reflections on photography could easily have served as a conceptual model for the Kodak Carousel pitch. Rather than recalling the past back into the present, Barthes argues, photographs attest to something in regard to the past they encapsulate—that which one sees in the photographic image really has been there, really did exist. If, in turn, each photograph certifies that what it represents actually happened, this also means that the person, event or scene depicted is irrevocably gone. The longing engendered by the work of photography thus involves less a staged memory, less a reconstitution of the past than the reality of a past mood; reality in a

past state. The uncanny quality of the sentiment or atmosphere that comes to be resuscitated by a photograph thus consists in the fact that it is "at once past and real."[27]

Decisive, however, is that Barthes does not want to think of this puncturing detail in terms of nostalgia. Given that nostalgia evokes something that no longer exists, it operates exclusively on the level of the imaginary. The unexpected and abrupt twinge that Barthes connects with the *punctum* of a photograph instead produces a wound in the order of the real. It speaks about that which was, by bringing the spectator himself into play. It compels the spectator to realize that he is the reference of every photograph; it generates astonishment by bringing the spectator to address himself "to the fundamental question: Why am I alive *here and now?*"[28] The fact that Don Draper accompanies his redefinition of the Kodak Carousel—it is not a space ship but a time machine—with a photograph in which he is resting his head on the belly of his pregnant wife opens up yet another connection to Barthes' investigation into the specific charm of photography. It is, after all, only after his own mother's death that Barthes came to finally articulate the real force behind the *punctum*. Photographs that touch him, that wound him, do so, he maintains, because they contain the imperious sign of his own future death.

The photograph of a pregnant Betty, can thus be read as the navel of the image sequence Don has assembled, given that it refers to a previous event even as it points toward the future.[29] It serves as a secret memory of his own birth, which is to say of the event that inaugurates the series of second chances that—as will be shown in more detail in the following

chapter—fundamentally determines his existence. He was allowed to survive the death of his mother. At the same time, this clandestine reference to his return from a somatically experienced death constitutes the counterpoint to the fantasy regarding a feeling of past security that, he claims, the Kodak Carousel allows one incessantly to retrieve. The charm of nostalgia requires both—a real wounding by the photographic image and an imaginary overcoming of this wounding. The photograph of the pregnant woman, of whom we discover at the end of *Mad Men* that she will die of lung cancer, and who implicitly doubles for the mother who was already dead in the first season of the show (even though she returns to the screen in a series of flashbacks in a later season), knots together two contrary emotions: a timeless pain that cannot be effaced (and thus continues to haunt) and the sentimentality that Don taps into when he proposes the fantasy of a happy past as an apotropaic protection against his current unhappiness.[30]

If, at the end of Don's overwhelming pitch, the two men from Eastman Kodak can only remain seated, staring bemusedly at the now empty screen in a conference room in which the lights have once again been switched on, we cannot be sure what has astonished them more—their own nostalgia that Don's presentation was able to capture or the successful manipulation that he so unabashedly has put on display. At the same time, this pitch scene also thrives on the fact that it functions like a mise en abyme for the time travel that *Mad Men* itself undertakes, and, in so doing, deftly refers to this TV show's own media strategy. At the beginning of the pitch scene we are in the position of the screen where this nostalgia-inducing series of images are about

to appear. Which is to say, given that we are initially in the position of the empty screen, the photos will be projected onto us. At the same time, in so far as we are initially looking directly at the assembled characters, enclosed within a circle of red light, we are also meant to reflect ourselves in them. By the end of this sales pitch, we have come to recognize the correspondence between the sequence of images from Don's personal past, with which he has charmed his audience on the one hand and, on the other, Matthew Weiner's own exploration of the past, given that it, too, is predicated on a visual series that jumps backwards and forwards in time. Each episode of *Mad Men* offers us a string of single and singular vignettes, revolving around one character or a set of characters. Knotted together, they touch each of us in a particular way, appeal to (and invoke) our very specific personal image repertoire, even while they count on our sentimental bond with the fate of these characters, thereby selling us the product called *Mad Men*.

In a typology of all pitch scenes, the acme of which consists in the one for the Kodak Carousel, we find on one end those sales pitches that, although they are invoked, we never see. Sometimes they are not represented because the product is not spectacular enough or because winning (or retaining) this account is a *fait accompli*. Then again, sometimes a pitch does not take place because the person who was meant to give it was detained. The most striking example for such a narrative ellipse, however, is the pitch for American Airlines in "Three Sundays," (MM 2.4) which the partners of Sterling Cooper and their troops go through with on Good Friday, 1962, even though they already know that they have lost this account. As

with a theatrical performance, the conference room is initially arranged to perfection, with even the smallest detail attended to. The long conference table is set with coffee cups and glasses, while salmon sandwiches and drinks are placed in the center of it. The presentation folders, bound in maroon leather, each bearing the individual name of one of the representatives of American Airlines, indicate the seating order. In the background we see the storyboards that creative has designed for print, television and media. Neatly placed on four easels, they are as yet covered, so that the advertisement strategy will only be disclosed to this illustrious audience in the course of Don's presentation.

While the final touches are being put to this theatrical stage-within-a-stage, Roger calmly does a stretch exercise, signaling that the curtain is about to rise. Then, assembling in front of the window, everyone assumes the position they have been assigned. At first, the camera gazes with them at the door to the conference room, as if sharing their keen anticipation. Then the door slowly opens and Herman 'Duck' Phillips (Mark Moses), their new executive accounts man, enters. His astonished gaze segues into a reverse shot that presents us with a group tableau—with Peggy Olson (Elisabeth Moss) and Joan Holloway (Christina Hendricks) on each end of the chorus line, while Bert Cooper (Robert Morse), in the center, is the only one already sitting at the table. For a few moments they hold the pose. While this pitch was conceived as their golden opportunity to prove themselves as players on Madison Avenue, this tableau vivant is also a film still, which serves to promote the second season of this TV show. The self-reflexive gesture

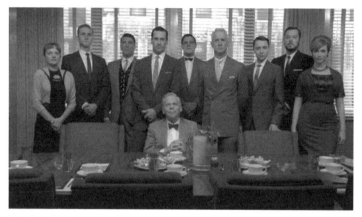

American Airlines sales pitch: Characters and actors conflate.

it offers up undermines the fictional pact. The people looking straight at us are both the characters in *Mad Men* as well as the key members of the cast.

Then, as 'Duck' begins to speak, confessing that their contact man at American Airlines has just been fired, animation once more sets in. The codes of business conduct require that they go through with the sales pitch even though they know they will be delivering a stillborn baby. We, however, never get to see this presentation, only the after effects—the food left over on the plates, napkins scattered over the table along with brochures that are no longer of any use. After Sal (Bryan Batt) has taken down all the visuals from the easels, the various characters, clearly disappointed, begin walking out of the conference room, until only Don and Roger are left sitting at the table. In order to compete for this major airline, they were obliged to give up their old client, Mohawk Airlines. Now they must face up to the fact that they have lost both. The marked elision of

this pitch scene thus signifies both the collateral damage of the advertising business and its specific charm. Whimsically, Roger explains to his despondent partner, "Sometimes it doesn't work out. Those are the stakes. But when it does work out, it's like having that first cigarette. Head gets all dizzy, your heart pounds, knees go weak" (MM 2.4). In the spirit of American optimism, the risk they have to take each time they try to acquire a new account is re-encoded as a creative impetus. Don's silence holds Roger's unchecked thrill of the chase at bay. The fact that, in their intoxicated rush for bigger business, they were willing to sacrifice their loyalty to the smaller airline renders visible the first fissures in the economic and ethical stability of this agency. At the end of the second season of *Mad Men*, Sterling Cooper will be up for sale for the first time, not least of all because of Roger's irresponsible behavior.

Don's passionate desire to win the Honda motorcycle account (MM 4.5) gives a different spin to sales pitches we never see, in this case because it never actually takes place. Allegedly dissatisfied with their current American advertisement firm, Grey, the Japanese decide to launch a competition between three other agencies. Each is given $3000 to prepare a presentation with storyboards and slogans. The rules of the competition however specifically state that no one is allowed to bring in finished work. Don, quickly realizing that they cannot win this race, nevertheless wants to attract the attention of the Japanese. Thus, instead of designing a campaign, he has recourse to a ruse. By making his rival, Ted Chaough (Devin Rahm) at Cutler Gleason and Chaough, think his team is in the process of making an expensive commercial, he hopes to trick

them into doing the same. Both agencies are too small to be able to afford undertaking such an audacious project. And yet, more is at stake than financially bankrupting their competitors (which obliquely gestures towards America's military strategy in its arms race against the Soviet Union). Don can also use this confidence game to put on display how effective the refusal to hold a sales pitch can be.

During the short interview, to which Don goes alone because he never informed his partners about his bold military ploy, he puts his complete trust into the power of public shaming. He accuses the two representatives from Honda and their translator of not having honored their own rules, explaining that this misconduct now compels him to withdraw his firm from the competition. While the three bemused Japanese men fall silent, he resolutely writes a check for $3000, thanks them curtly and leaves the room. As in previous pitch scenes, aggression is skillfully put to dramaturgic use, emerging as the flip side to seduction. The Japanese, falling for the trick, are utterly charmed with Don Draper's idiosyncratic gesture. They never had the intention of leaving their old advertisement agency in the first place. They simply wanted to test the field for the little car they hope to launch next in America. The fact that Don draws their attention with his non-pitch, however, also brings into view the vacuum around which all successful advertisement revolves. The battle, once again, involves not only a particular product but also a surplus of desire. It gestures towards the nebulous dream of making it.

As a counterpoint to scenes in which the actual pitch is cancelled (or not shown), *Mad Men* also makes dramaturgic use of

scenes in which the sales pitch is overdetermined, not least of all because more than one thing is being offered up. This becomes most conspicuous when the mood of seduction, so much part of Don's subtle *modus operandi*, becomes the unsavory focus of his presentation and thus all too visible. Excess value and face value come to conflate, as is most prominently the case in the sales pitch for Jaguar. Here, the use of parallel editing serves to underscore unequivocally the ugly reality on which, in this case, Don's rhetorical brilliance is predicated. While the clichéd analogy between a desirable car and a beautiful woman was, from the start, the tenor of Don's advertisement strategy, Herb Rennet (Gary Basaraba), the head of the car dealers association, makes a demand that sheds an openly obscene light on this rhetorical analogy. Only if Joan is willing to spend the night with him can Sterling Cooper Draper and Pryce (SCDP) count on his support. Insisting that their creative work would be good enough to hold up against such an outrageous request, Don leaves the meeting prematurely, allowing the rest of his partners to vote on this business without him. Joan, in turn, shrewdly seizes this indecent proposal as an opportunity for her own self-advancement. Realizing that the partners are in no position to refuse her demands, she is able to broker a deal for partnership with a 5% profit shares in the firm.

The next day, Don, unaware of this turn of events, once again stands in front of the easels that display his storyboards, in this case visual fragments of a red Jaguar. His opening line is so general that it could pertain as much to the particular car in question as to any other luxury product: "When deep beauty is encountered, it arouses deep emotions; because it creates

a desire" (MM 5.11) Yet the mise-en-scène undermines this unrestricted definition of desire by visualizing the actual incident of seduction that took place the evening before. Spectrally present in the room, hovering over the visuals that make up the backdrop for Don's speech, is the particular beautiful woman who created a desire in his powerful client. The intangible fantasy that Don evokes, so as to captivate his audience, and the concrete realization of an erotic demand are shown to be inextricably entwined. While we continue to hear Don's voice, explaining that what makes deep beauty so desirable is that it is, by nature, unattainable, a flashback shows us Joan, knocking on Herb Rennet's door and entering his hotel room. Throughout the pitch scene, the parallel editing oscillates between Don's story about objects of desire that seem to be out of reach, and the flashback that shows Joan to be an object of desire very much in the hands of the lascivious car dealer.

The uncomfortably cynical tone of this scene has, in part, to do with the fact that Don's presentation emerges as the rehearsed recycling of previous presentations rather than being yet another example of his inspired genius. It also produces a sense of unease, however, because, pitted against the nebulous desire that Don invokes, we are made privy to an embarrassing sexual encounter that lays bare the sexism inscribed in an advertisement campaign that implicitly equates cars with women's bodies that remain out of control, that are always speeding out of reach. At no moment, however, does the woman, on whose willingness to comply with the ugly demands of the men the pitch depends, appear as a victim. Joan performs the part she is compelled to play with silent dignity, even while allowing

us to recognize how painful it is for her to go through with this act. The fact that her one-night stand remains oblivious to this pain only renders more poignant the discrepancy made obvious in the parallel editing of these two scenes. The final part to the story Don has to tell, leading up to the slogan—"Jaguar. At last, something beautiful you can truly own"—involves a final touch regarding the deep desire that beautiful things can provide. For his all-male audience, Don evokes the image of a man of some means, who, while reading *Playboy* or *Esquire*, flips past the centerfolds to enjoy instead the shiny painted curves of this luxury car. Though nothing would stop him from lingering over the naked models instead, the difference, Don asserts, is that while these can be possessed in mind only, "he can actually have a Jaguar." The editing pointedly moves one more time to Herb and Joan briefly lying in bed together, his sexual demand satisfied, before Joan, without saying a word, gets up and leaves the hotel room.

In three respects, Don's persuasive powers come to be debunked in this pitch scene. Firstly, the advertisement slogan he is offering to his clients screens an ugly truth. As we have just been shown, the man of means, whom he targeted as the ideal buyer of a Jaguar, can have the woman he desires along with this luxurious car, as long as he is both powerful and unscrupulous enough. The very sense of happiness that in the other pitch scenes is sold as an imaginary surplus along with the actual product, here emerges explicitly as a fantasy meant to cover up an obscene reality, which at least some of the men present in the room are privy to. Secondly, given that no remorse is shown, what this pitch scene also discloses is the price the

partners of Sterling Cooper Draper Pryce are willing to pay, the behavior they are willing to condone, in order to achieve their goals. Don's sales pitch thus also speaks to the toxic underbelly of the American dream, though this is not his explicit intention. Ironically he was the one to draw attention to the difference the Jaguar account would make, given the precarious financial recovery of their agency: "Every agency on Madison Avenue is defined by the moment they got their car. When we land Jaguar, the world will know we've arrived" (MM 5.10). Finally, Don's sovereignty as head of creative is also undermined in yet a third sense by the fact that, although he sought to prevent Joan from going through with this distasteful business, his advice came too late. He can now never know with certainty whether his presentation alone was responsible for their acquisition of the Jaguar account they so fervently wanted or whether the deal his partners made behind his back ultimately won over their client. In any case, the moment Joan walks into the first partner's meeting, no longer as the secretary but as a full-fledged associate, he is forced to acknowledge that he has himself been conned.

Nowhere, however, does the fragility of happiness, as the clandestine kernel of all the pitch scenes, surface as acutely as in Don's attempt to win the Hershey's account. It, too, represents a moment of genius, even if it is the pitch that almost costs him his own career. And here, too, an overabundance of information is at play. In contrast to the Jaguar presentation, the ugly inversion of the sales strategy Don has prepared for this product is not represented with the help of inserted flashback/ parallel sequences. Instead, by presenting first one and then a second sentimental boyhood story, he foregrounds the mutual

implication between happiness and the sense of privation it is meant to cover up. At the same time, this is the culmination of all sales pitches, not only because it takes the notion of playing with the confidence of one's audience to an extreme, but also because it picks up on and refigures aspects from previous pitch scenes. As in the aggressive rejection of the Honda people, Don once more proves his willingness to take risks, even while, as in the presentation of the Kodak Carousel, he draws on nostalgic self-recognition. In this case, however, another element is added: namely the discrepancy between two memory scenes, putting into question the interpretive prerogative that the advertisement industry makes claim to.

For his presentation, Don requires only one easel. Flipping around the one visual he has so as to display the iconic chocolate-brown wrapper with its silver lettering, he explains: "the product itself is one of the most successful billboards of all times." Indeed, what he is selling is not a new visual design but rather a different way of telling the story for a product intricately interwoven with the American way of life. By the 1960s, the Hershey bar had long since become a mythic signifier, referring both to a piece of chocolate and to a collectively lived fantasy. To the men, sitting around the table in quiet anticipation, Don proceeds to relate what he initially maintains to be a happy story from his own childhood. Grinning smugly, he recalls how, after he had mowed the lawn, his father once took him to the drugstore, where, although he could have anything he wanted, he chose a Hershey bar. While he was ripping open the wrapper, he adds, his father tousled his hair, so that forever, in his mind, paternal love and the enjoyment of this particular

chocolate have remained tied together. The nostalgic point of the story he proposes to tell in the campaign he has designed is that "Hershey's is the currency of affection. It's the childhood symbol of love" (MM 6.13). Both the clients as well as the partners present at this meeting seem to be perfectly content with an advertisement strategy that focuses on sweet tales of childhood, and yet, even while Don sits down at the table with them, he realizes how insipid his all too brief presentation has been. The slogan, equating this chocolate with childhood happiness is not only a cliché without any expressive force but also without any real significance for Don, not least of all because it completely contradicts his own experience.

Thus, after hesitating briefly, he begins anew, once more driven by the spontaneous inspiration of an inner voice. Only now, as though speaking to himself, he turns the pitch into a public confession, offering an intimacy that none of those present want to be privy to. The second story he tells serves as the bleak counter-version of the previous reward scene, disclosing, as it does, the sad fact that, as a boy, he had neither the protective home nor the loving parents at the heart of so much fantasy work. Instead, one of the prostitutes working in the whorehouse in Pennsylvania where he grew up as an orphan was the one who bought him Hershey bars. And she did so repeatedly, whenever he was able to collect more than a dollar while going through her john's pockets. Almost in a whisper, Don continues with his embarrassing divulgence: "It said 'sweet' on the package. It was the only sweet thing in my life." Even though the other men are clearly uncomfortable by the impropriety of his confession, Don is still not finished. The self-doubt that has

taken hold of him requires a further debunking of the confidence game on which the advertisement business is predicated. The confidence he seeks to share with his dumbfounded clients (and partners) requires that he radically abnegate his own métier. If it were up to him, he confesses, he would advise them never to advertise, because they need no creative director and no TV commercials to tell a young boy what a Hershey bar is: "He already knows."

This claim entails a scandalous moment of truth in more than one sense. By calling into question the seductive deception around which all sales pitches revolve, he has broken the rules of the game. At the same time, the point of his second, mortifying story pits a scene of real emotional deprivation against the fantasy image of loving affection he had initially presented. If, during the Kodak pitch, he had made use of personal snapshots so as to invoke an idealized notion of the family as a site of security and well-being, he now provides his audience with an insight into his past that will allow for no sentimentalization. The "sweet tales of youth" with which Sterling Cooper & Partners (SC&P) hope to advertise the Hershey bar are not only shown up to be an illusion. Such slogans, Don implicitly suggests, also encourage the consumers of this product to avert their gaze from acknowledging the gaps and fissures in childhood happiness. As such, the scandal of this anti-pitch also pertains to a zero point in advertisement because the surplus of desire that it alludes to is brought into focus directly. What Don's inner voice compels him to address is not only the satisfaction that the Hershey bar once afforded him, but also the fact that this served as a bodily compensation for emotional distress, namely

the terrible sense of not being wanted. And yet, as he himself knows only too well, like the reference to the death drive he repudiates regarding Lucky Strike cigarettes, any open avowal of compensation as the motor behind mass market consumption would make bad copy for a billboard.

Don's confession, one could surmise, proves to be the *punctum* of the entire sequence of pitches leading up to it because, while it is not the first to make use of aspects of his personal life, it is the first and only one that involves a memory that is painful to him precisely because it is at the same time past and real. As such, it is also the one pitch in which he undermines his own plea for nostalgia. His point, after all, is that any advertisement deploying stories of childhood that appeal to an imaginary desire would simply equate this chocolate bar with other desirable sweets. He, however, wants to insist on the uniqueness of this particular product, so as to preserve the uniqueness of his pain as well. The Hershey bar wrapper, so utterly distinct to him, is not to be subsumed into an arbitrary series of advertising images, because, by extension, that would deplete his own story of its intimate particularity. The fact that, with his double pitch, Don merely replaces one sentimental boyhood story with another, less savory one, however, represents a scandal in yet a further sense. What becomes clear is that there is no escape from the circuit of imaginary resolutions for real personal conflicts. One can only hold on to the difference between those fantasies that satisfy by covering up current discontent and those fantasies that preserve past pain because this ugly memory, also, offers a kind of satisfaction.

While, rather than ending Don's career in advertising, this anti-pitch merely forces him to realize how intimately his existence is tied to his métier, it is also not the last sales pitch we see. Instead, *Mad Men* culminates in a final sales pitch that puts an end to all further pitch scenes because involved, now, is the survival of the agency itself. Towards the end of the seventh season, the partners of SC&P finally discover that, contrary to their agreement with Jim Hobart (H. Richard Greene), McCann Erickson is about to subsume them completely into the bigger company. To preserve the integrity of their small agency, Don comes up with a last survival strategy. He proposes to the other partners that they open up a subsidiary company in California, taking with them the handful of clients they would have to give up because of a conflict of interest.[31] The next morning, Don and his partners arrive early to the meeting at McCann Erickson, because, once more, they want to set up a stage for their performance. After Jim Hobart and his right-hand man have entered the room, everyone takes a seat except Don. He launches into their self-pitch by pointing out the financial gain their move to the West Coast would entail. He has already flipped over the board displaying the new Logo—"Sterling Cooper West, A Division of McCann Erickson"—when Hobart interrupts him. This is the only time in *Mad Men* that Don is forced to stop in the middle of a sales pitch.

The wily head of McCann Erickson, having seen through Don's con game, now turns the tables on him and his partners. Asking Don, who is deeply irritated by this interruption, to have a seat, Hobart begins with his own counter-pitch, based on persuading them of the imaginary surplus that will go in tandem with the

Sterling Cooper West sales pitch: Final group portrait of the partners of Sterling Cooper.

proposed fusion. At first, he flatters them by assuring them that they have passed the test: "I shouldn't have to sell you on this. You are dying and going to advertising heaven" (MM 7.11). He then proceeds to lure them with the promise that they are about to get some of the most coveted jobs in advertising, along with the resources that go with these. Demonically he tosses a magic name to each of the men present: Buick, Ortho Pharmaceutical, Nabisco and Coca-Cola. This is an interpellation that they cannot refuse. His final advice, "stop struggling, you won," only serves to underline their own ambivalence. Quiet desire begins to flicker on their faces. Only Joan, who is left empty-handed, sees through the deception. Even after Hobart has left the room, they remain seated, stunned and silent. Analogous to the thwarted pitch for American Airlines, the camera offers us a final *tableau vivant*—a last group portrait of the five remaining partners of the late SC&P, placed in front of the Midtown skyline with Don sitting in the middle. They will soon go their

separate ways and they know it. It is no coincidence that Hobart is the head of McCann Erickson. He surpasses them as a con man, indeed, he has tricked them from the beginning, and yet they can do nothing but give in to a deception that he is selling to them as a victory. The power of big money and of the advertisement business stands behind him.

At the same time, this is again a group portrait of the cast members, who, by acting in *Mad Men*, gained global celebrity, yet whose fictional alter-egos will die off at the end of this final season. The sales pitch scenes in *Mad Men*, with which Don's creative genius had repeatedly come to be reinstalled and whose affective as well as rhetorical features bear his signature, have come to an end.[32] They will not be repeated. One last time we are manipulated into bonding sentimentally with the desires of these characters, even as we are made fully cognizant of this manipulation. Hobart's intervention only serves to underscore how utterly candid Matthew Weiner's show is about the fact that the persuasion remains on the surface of the images—those produced by his advertisers and those he himself produces. Thus, to the end, sentimental bonding and ironic distance work hand in hand. At the same time, if we think through these pitch scenes from the end point, we come to recognize how they have carried forward the over-arching narrative argument of this TV series, beginning with the moment of inspiration that overcomes Don during the Lucky Strike pitch. Passing through the many scenes of seduction, during which Don and his team promote an idea about a product even while they fight for their position on Madison Avenue, this narrative trajectory reaches its logical resolution in their final success. When they

have actually arrived on Madison Avenue, when they have fully achieved the goal that has kept them going throughout these seven seasons, they have also attained a consistent conclusion for two projects that were, from the start, enmeshed—the agency Sterling Cooper and the series *Mad Men* itself.

Beyond the Happiness Principle

Our life is an apprenticeship to the truth, that around every
circle another can be drawn; that there is no end in nature,
but every end is a beginning; that there is always another dawn
risen on mid-noon, and under every deep a lower deep opens.
Ralph Waldo Emerson

The confidence game inherent in each of the successful pitches
with which Don seduces his colleagues and clients alike touches
upon the core of his own person as well. The name he has as-
sumed is significant in several ways. If his first name phonetically
calls up the word 'dawn,' it also evokes the incessant striving
towards a new day, which the American dream so emphatically
proposes. His surname, in turn, points towards an act of dis-
guise and dissimulation, given that 'to drape' not only means
wrapping a piece of cloth loosely around a part of the body,
but also to adorn or to cover up something with the folds of a
piece of cloth. In other words, the name which, owing to a lucky
coincidence at the Korean front, Pvt. Dick Whitman chooses
to assume surreptitiously itself signifies a cover-up. As some-
one who has achieved his success on Madison Avenue under
an assumed identity, behind which a far less glamorous one is
hidden, Matthew Weiner's con man, of course, recalls F. Scott
Fitzgerald's WWI veteran, who, in *The Great Gatsby*, also rede-
fines himself anew several times so as to compensate for prior
losses. And yet, as the Hershey's sales pitch discloses, there is
a further reason why Don Draper can be seen as a successor to

Jay Gatsby. Having recourse to the past, holding on to and invoking past experiences, entails a movement backwards regardless whether the person one once was comes to be nostalgically idealized or soberly debunked.

If the American dream thrives on the conviction that happiness and moral perfectibility can be achieved in the future, what, in turn, propels the archetypical American hero in the opposite direction are the very memories of past events that are meant to be surmounted, and thus left behind. Refusing to let go of what once happened in the past is, ironically, the reason the archetypical American hero needs to constantly move on in the first place. Hardly a literary passage is as precise in articulating this contradiction as the famous last paragraph of *The Great Gatsby*. The night before the narrator, Nick Carraway, leaves Long Island, he returns once more to the mansion of the fantastically rich, mysterious man who had been his neighbor, and then turns to look out at the moonlit shore. As the moon slowly rises higher, Nick, brooding on the old, unknown world out of which the modern metropolis Manhattan has grown, begins to imagine the wonder his friend Gatsby must have had, when he first detected the green light at the end of the dock of his beloved Daisy Buchanan: "Gatsby believed in the green light, the orgastic future that year by year recedes before us. It eluded us then, but that's no matter—tomorrow we will run faster, stretch out our arms further... And one fine morning—So we beat on, boats against the current, borne back ceaselessly into the past."[33]

Draper's charismatic appearance similarly thrives on a conflict between striving towards the future and the pull of recol-

lection. Even if he is the one to assure others that one can, and must, cut one's losses and move forward, it is inevitably his own past that catches up with him and, in doing so, repeatedly draws him beyond the very happiness principle his advertisement campaigns so vehemently promote. He is, thus, the living embodiment of a confidence game in yet another sense. Even while the way he presents himself to others and the actions he undertakes are draped in the conviction that there will always be a new day, his thoughts repeatedly move towards that which once happened—the past he has emerged from and which he cannot, at least not yet, let go of.

This internal struggle is rendered visible early on in *Mad Men*. After resolutely repudiating Dr. Guttman's claim that the death wish is as powerful a drive in psychic life as the drive towards procreation and the wish for survival, Don lies down on the sofa in his office and falls asleep. When Peggy comes to wake him because the people from Lucky Strike have arrived, he still has the sound of bombs exploding on the front line in Korea in his ear. Don's denial of a death drive beyond the pleasure principle thus emerges as the key to the persistence with which his memory work serves as a counterpoint to the inspired sales pitches that stake everything on the promise of future happiness still to be attained. In the flashbacks that punctuate the narrative flow, we are given a scenic representation of the psychic division which, vis-à-vis the Adlerian psychoanalyst, Don claimed to be absurd a little earlier. As Don finds himself compelled to resuscitate painful or confusing scenes from the past, the two things shown to be inextricably intertwined are his outward will to survive and an internal drive towards self-destruction. The

latter repeatedly pushes Don close to the brink of complete failure. The montage technique deployed in these flashbacks, in turn, cinematically performs these two conflicting desires. By interpolating past scenes into the present, the editing seamlessly splices together two temporally different sites, and, in so doing, discloses Don's double consciousness.

The very first flashback we see involves Don's war experience in Korea. In the shape of a daydream, it recalls into the present the secret past on which his desire to live a life of success, prosperity and social recognition in New York City is founded. Yet with this flashback, a further contradiction is also brought into play early on in *Mad Men*. The force that once drew (and continues to draw) Don into the realm of death is also revealed to be the catalyst for his present success. It is what allowed him to become the charismatic figure he now is. Furthermore, even while he desperately wants to preserve the secret of this war scene, he also does not want to forget it because it functions as a precious memento for the present, encapsulating as it does the productive power of risk. Thus, Don's revisitation of the war scene in this daydream is evidence not of any sustained trauma that may compel the psychically injured veteran to return to the site of his wounding, as is so often the case with those who suffer from a post-traumatic stress syndrome.[34] Rather, it concerns a memory that he has carefully retained in his mind, much like the box of private papers and family snapshots which he has hidden in the desk in his office at home because this material would divulge his former identity, along with the identity theft he is guilty of. Thus, potentially threatening to his self-fashioning is, above all, the fact that he clings to the very paraphernalia

of the past, whose concealment is the precondition for his current success and happiness. Lurking barely beneath the surface of the deception by which he lives, these meaningful memories are always on the verge of erupting into and thus destroying the life he has so diligently created for himself, not least of all because he willfully entertains the possibility of letting them do so.

Furthermore, what is decisive for the way he has retained the scene of his audacious identity theft at the war front is the fact that this is no coherent memory but rather an imaginary reconstruction of the past. The flashback begins with Dick Whitman (Don Draper's former identity), arriving at night at a lone outpost on a hill in Korea, where his commanding officer is supposed to set up a field hospital. It quickly moves to the next morning, with Pvt. Whitman busily digging a trench when the enemy attack sets in. Together with the real Don Draper, he immediately jumps into the shallow furrow he has already dug, both cowering there while the bullets pass over their heads. The barrage stops as suddenly as it began, and, gasping for breath, both men get up. Sgt. Draper, who has begun to laugh, lights a cigarette and Whitman follows suit. Then, with a note of derision in his voice, the officer points out to his subaltern, "You pissed yourself" (MM 1.12). Astonished, Dick looks at the wet spot on his pants and, as he tries to wipe away the shameful traces of his fright, drops his open lighter. If the trench was still completely dry before the barrage set in, the ground is now covered with a stream of explosive fluids. Although, during the attack, our attention was drawn to the fact that a few bullets hit the gasoline canister hanging close to where Pvt. Whitman

had begun to dig, the montage allows for a further association. His embarrassing body fluids are what gets the lighter to ignite, which he inadvertently let fall to the ground in response to being shamed by his superior. How it was possible for the small fire that has erupted in the trench to transform into the enormous explosion that kills Sgt. Draper is rendered as a gap in the memory of the survivor. In the flashback, the entire scene dissolves into a glistening white light, transitioning to the hospital where the survivor, whom the corpsmen were able to rescue, has been brought.

Thus, while Dick proves to be responsible for the death of his commanding officer, he also owes his new identity to this unintended killing. This death, furthermore, not only makes it possible for him to leave the theater of war soon after. Rather, the exchange of dog tags also makes it possible for him not to return to the very home which to flee he had joined the army in the first place. And while it remains ambiguous whether he might not have dropped the lighter as an unconscious reaction to his shame, in retrospect this gesture is unequivocally a sign of self-empowerment. In his daydream (regardless whether it is an accurate memory or not), Don takes revenge against the man who mocked him, even while this retaliation is also the mark of his own survival. Despite his fright, he, in contrast to his commanding officer, was able to assert himself against death, indeed he was canny enough to turn the fatal explosion to his advantage. In the following scene, we see the man who was admitted to the hospital under the name Don Draper lying in his bed, already in a state of convalescence. While an officer pins a purple heart medal on his right shoulder, the survivor

silently remembers his bold sleight of hand. Several short sequences, spliced into this scene to produce a series of inserted flashbacks within the overarching flashback, disclose how Dick stole the dog tag from the burnt corpse of his superior, placed it around his own neck, and then threw his own dog tag into the ashes still burning in the furrow he had dug. The parallel editing within the flashback—oscillating as it does between the man convalescing in the hospital and the man surviving a furious explosion on the front line—draws our attention to the fact that this daydream revolves around a multilayered confidence trick. Dick is not only *not* the man (Don Draper) he pretends to be, but he is also being decorated for heroism, when, in fact, he is not only *no* hero, but actually guilty of manslaughter.

As Sigmund Freud has pointed out, the work of fantasy hovers between three temporal moments involving our ideation: "Mental work is linked to some current impression, some provoking occasion in the present which has been able to arouse one of the subject's major wishes. From there it harks back to a memory of an earlier experience […] in which this wish was fulfilled; and it now creates a situation relating to the future which represents a fulfillment of the wish […] Thus past, present and future are strung together, as it were, on the thread of the wish that runs through them."[35] Don's work of memory indeed corresponds to a dream formation, given that issues that have been bothering his conscious mind over the past few days flow into this imaginary reconstruction of his past war experience, even while his act of remembering also shapes the decisions he is about to make regarding his future. After all, the flashback is triggered, on the one hand, by the sudden appearance of his

actual half-brother Adam (Jay Paulson), who wants to be part of the family life that Don is now living under his assumed name. The war memory allows Don to convince himself that he cannot give in to the emotional pressure Adam is asserting on him; that he must continue to ruthlessly repudiate his own kin. In response to the emotional cruelty of being cast off by his brother, Adam will take his own life, his corpse a somatic manifestation of the affective death Don's rejection signifies. On the other hand, the flashback is also Don's answer to Pete's threat that he will denounce him as a liar and a deserter in front of Bert Cooper. Fortified with this retrieved war memory, Don silently stands in the office of the man who is now his superior on Madison Avenue, awaiting his verdict. Ironically, far from shaming him, the disarming response the wise founder of the agency has in store confirms the accusation made by his rival, even while it completely absolves him: "Who cares? This country was built and run by men with worse stories" (MM 1.12).

If it was the possibility that Pete's disclosure might disturb (and perhaps even destroy) the image that Don has fashioned of himself that sparked his memory regarding the origin of his double existence, the end of this flashback sequence renders visible that Don's return from the war was itself uncanny in more than one sense. Fantasy work's enmeshment of temporal moments is evident in this case also. His daydream boils down to the fact that he was able to successfully avert returning to his actual home, even while this abnegation of family ties in the past continues to leave its traces in the present. While Don was still convalescing in the hospital, he was asked to accompany his fellow soldier to Bunbury, where he was to be buried under

the name of Pvt. Whitman. Once the train arrives there, however, Don refuses to disembark because, among the mourners waiting on the platform, he recognizes his own family. Instead, he remains standing in the aisle, watching through the window as the coffin, containing the corpse now bearing his name, is carried out of the train. Then he notices that Adam, having recognized him, is waving to him, and, indeed, runs alongside the train for a few moments, as it begins to leave the station. What we are presented with is a significant double portrait. Don has brought himself home as a man slain in battle. With the identity theft, he has given himself the name of a man who is now dead, even as he has attached his own name to the other man's corpse. From now on, he will live on as the ghost of himself *and* as a revenant of this dead man. Serving as the narrative closure for the episode "Nixon vs. Kennedy," and as such coming after Bert Cooper has unequivocally taken Don's part in the conflict with Pete, we are shown a different homecoming, equally ambivalent. At the end of this emotionally taxing day at work, Don is finally able to return to his home in Ossining. The kitchen is dark and Betty, lying on a sofa in the living room, has fallen asleep in front of the TV set. As Don enters, Nixon is holding his concession speech. Silently Don remains standing next to her. This double portrait offers a poignant counterpoint to the one of the family that he repudiated upon returning stateside. The image of his wife, present but unaware of his presence, perfectly encapsulates the fragile happiness of the new family that he was able to found given his supreme confidence game on the war front.

At the same time, this first flashback renders visible a survival strategy in which Draper casts himself as the hero of his own fate. In the face of the complete loss of control engendered by the enemy attack, he proved himself capable of resorting to a gesture of self-reliance, as audacious as it was spontaneous. Seizing the opportunity that the accidental death of his commanding officer afforded, he was able to forge a new future for himself. Destructive creativity thus emerges as the flip side of the inspired genius that just as suddenly came over him during the Lucky Strike pitch. Yet it is also this bold courage that repeatedly draws him back into a past that he does not want to let go of because it is too valuable to him. The box with the family snap shots that Adam sends to him just before committing suicide, and which Pete will make use of in his attempt to smear him in front of Bert Cooper, will actually cost him his family life in Ossining. As such, this box functions like a covert site, comparable to a crypt, where everything that he must keep secret, yet which he is also not willing to relinquish, can, like an intimate treasure, be preserved. These snap shots, with his actual name, Dick Whitman, written on the back, along with the various documents that attest to his prior identity, are evidence of the fact that the allegedly happy family life he has tried to create with Betty is predicated on an irredeemable deception. The fact that he is unwilling (or unable) to part with this incriminatory evidence, however, also allows for a further speculation. Don not only draws his ability to ruthlessly assert himself as the creative director of his agency from precisely the memories of a past that he must repudiate towards others. A clandestine death wish

also persistently tempts him to risk everything such that his duplicitous life might finally collapse.

In perfect pitch, Betty articulates precisely this contradiction when she, in turn, uses exactly these hidden family photographs as evidence to support her accusation that he has destroyed their happy home: "You obviously wanted me to know this or you wouldn't have kept all of this in my house" (MM 3.11). Don evades giving a straight answer. The double life that compels him to float between the present and the past may be hard to bear. Yet he cannot abandon the ghosts from the past that disturb his current life, because he also yearns for an authenticity beyond the deception on which this fragile happiness is predicated. The quiet despair, which, from the beginning, accompanies Don Draper's self-confidence like a shadow, attests to this ineluctable emotional aporia.

It is, thus, useful to recall that Alexis de Tocqueville already discovered in American democracy a very particular shaping of individualism. Precisely because American subjects have become accustomed to thinking of themselves always in isolation, they have also enjoyed convincing themselves "that their fate lies entirely in their own hands." This conviction, Tocqueville concludes, leads each man "back to himself and threatens ultimately to imprison him altogether in the loneliness of his own heart."[36] If the audacious sleight of hand on the front that allowed Don to flee from two unbearable situations—his foster home and the confusion of battle—proved to be an act of radical self-reliance, it comes at a steep price. Precisely because he was able to shape for himself a new life, independent of all natural family ties, he can only rarely speak about himself to

others—and even then only in fragments. Preserving his artful and elaborate confidence game prevents any open communication with others. Fundamentally self-reliant, he is also completely alone with himself, enveloped in his singular ghostliness.

The contradiction Don Draper so viscerally embodies, is, however, even more complex. His emotional attachment to the past not only compels him to dwell simultaneously in various time periods but also repeatedly precipitates him into situations that could result in complete failure (and with it a total collapse of his world). And yet this psychic ambivalence is also—as the credit sequence so pointedly demonstrates—the necessary precondition for a new beginning. It is as though he had fully internalized Emerson's dictum that "the new position of the advancing man has all the powers of the old, yet has them all new. It carries in its bosom all the energies of the past, yet is itself an exhalation of the morning."[37] Don must first fall to the very bottom in order to land again with both feet on the ground. In order to find recovery, he must first lose everything. Throughout the seven seasons of *Mad Men*, he thus resiliently performs the very logic of an indefatigable pursuit of self-creation and self-determination, which resides at the heart of the American dream. If the word 'dawn' can be heard in the first name that he acquires by surreptitiously exchanging dog tags with his slain superior, this name also indicates that his risky and creative game with identities is predicated on the confidence that he will always be given yet another second chance.[38] Emerson's celebration of self-reliance requires of the American subject that he must demonstrate his willingness to pursue greater possibili-

ties and moral perfectibility over and over again. After all, only he who is willing to risk failure and be completely unsettled can hope to rise again and reassert himself. Cast as the archetypical American hero, Don, in other words, must not only repeatedly go to the limit, undermine his own success at every turn. If a death drive is part of the fabric of his success, he is also allowed to put everything into jeopardy because he (and we with him) can be confident that for him there will always be a new day. He may be a dead man walking, and in his ghostliness often find himself standing next to himself, but he is also unequivocally a survivor.

Indeed, Don not only returns from the war as a man resuscitated from death, literally having taken his new identity from the bloody viscera of a slain man, but this existence, so vehemently wrested from death, is also haunted by a past rich in fatal events. This attests to the way the very death wish beyond the pleasure principle, which Don so emphatically repudiated during his discussion with Dr. Guttman, does in fact inhabit his psychic life in multiple ways. To begin with, the killing off of his prior identity in Korea is only the most extreme form of self-creation in a sequence of second chances that punctuate the various turns his biography takes. If the death of his mother in childbirth left him abandoned, in a fundamental sense a stranger in his world, this loss of family bonds is repeated when he signs up to join the Army. After his return from Korea, a further second chance opens up in the fur business, then another one in his marriage to the well-to-do Betty Hofstadt, and finally in the con game he has recourse to so as to get Roger to employ him as a copy writer at Sterling Cooper. Don demon-

strates a further knack for second chances when he repeatedly persuades his partners to found a new agency in their effort to ward off a merger with McCann Erickson, but also when he resiliently reclaims his position as creative director after the fiasco of the Hershey's sales pitch. The covert desire for self-destruction underlying his resilient self-reliance, in turn, reveals itself in the fact that he is compelled to traverse various stages of his despair, and, repeatedly fleeing both from his family and his workplace, finds it necessary to fully embrace his solitude. Indeed, Don must take his alcoholism as well as his adultery to an extreme, must reach down into the very core of his deep-set self-doubt, before he can once again, at the end of the seventh season, return, having recovered the full force of his creative potential with the Coca-Cola commercial. The many crises that put his resilience to a test, the many emergencies that allow him to enjoy his own fallibility, prove to be utterly necessary for his creative genius to unfold. After all, in order to retrieve self-confidence it is necessary to experience the loss thereof.[39]

At the same time, the flashbacks and hallucinations that scenically enact Don's conversation with himself give voice to a death wish in yet a further sense. Intermittently, this psychic self-questioning also places him in a world apart, allowing him to stand next to his ordinary, everyday self, and observe himself as his own double. In this memory work Don seeks out the deceased in the hope that they might have some advice for him regarding his current dilemmas. His quiet despair, harking back to his fundamental sense of not being at home in the world, thus concerns not only the fact that as a seasoned confidence man he is condemned to a life of solitude. Rather, his memory

work also repeatedly turns him into a visionary, a seer of ghosts. His flashback visions from the past, usually darkly illuminated, represent a different kind of epiphany. They offer a satisfaction of their own to Don, not so much in that they clear up something. Instead they draw his attention to something which, although it happened in the past, continues to have its effect in his sustained discontent *in* and *with* the world.

If Don is often overcome by the strange melancholy that Tocqueville discovered at the heart of the American democracy along with a cruel solitude, this brings with it a sustained memory work, allowing him to delve once more into a time when he was neither prosperous nor successful. In these retrieved scenes he assumes the role of silent observer, seeking to discover why the idea of happiness, which he so skillfully promotes in his sales pitches, seems constantly to recede from his grasp.[40] Sometimes these scenes circle around his own beginning—the death of his mother and the stillborn child of Abigail Whitman (Brynn Horrocks), whose place he assumes in the family of his biological father. Other times, they evoke the destitution and moral depravity of his childhood, as though to caution him not to end up in the same abject condition as did his father. The latter had been fatally wounded by his horse while attempting to mount it one night in a state of drunken stupor. Most of the flashback scenes—with the exception of those vignettes from the past that attest to his deep friendship with Anna Draper (Melinda Page Hamilton), the wife of the actual Don Draper—not only give shape to the sad underbelly of the family happiness his advertisement campaigns tend to invoke. They also cast a new light on the idea of the emotional

reassurance nostalgia affords. During his Kodak sales pitch, Don was able to discover a sentimental yearning for his family life with Betty once seminal moments from his life in Ossining presented themselves to him as a series of snapshots. His flashbacks, in turn, bring a different kind of belated knowledge into play. Although, under no account, does he want to return to this world, knowing as he does that he was not loved there, the family scenes he retrieves in these memory scenes also do not represent something lost. Rather, this painful past continues to be emotionally real and present for him. As such, the psychic contradiction his death wish gives voice to pertains to a different aspect of the uncanny. Don is not at home in the present, feels emotionally estranged from it, because he has neither succeeded in abandoning his prior desolation nor can he translate this precariousness into the nostalgic image of lost security. As his arsenal of personal phantoms, the figures of the past give body to the void at the heart of his desires and his ambitions in a manner necessary for his creativity and his self-knowledge.

Like the flashback scenes, the hallucinations that the dead allow him to be privy to also contain messages for the present. Sometimes these involve his notorious adulterous infidelity. In a particularly gothic dream, he murders a former lover who has clandestinely slipped into his bedroom, insisting on a sexual encounter he initially resists. Then again he sees apparitions of the two women to whom he was able to speak openly about himself, at the moment of their dying. Anna Draper appears to him holding her suitcase, while Rachel Katz (Maggie Siff) appears to him during an audition for a fur coat ad, and, as she leaves the room, warns him not to miss his flight. In another

episode, the suicide of his partner Lane Pryce (Jared Harris) calls up the apparition of his half-brother Adam, whose spectral presence Don proceeds to espy all over the office. Or, during a wild, drunken party in L.A., the hallucinatory figure of Pvt. Dinkins, of whom Don knows that he died in Vietnam, leads him to the edge of a swimming pool, where he sees his own floating corpse. Don accidentally exchanged his army lighter (one of the few memorabilia he had kept from his time at the Korean front) with this G.I. in a bar in Hawaii, before serving as his best man at the wedding that took place the next morning.

Comparable to Don's memory work, these hallucinations also offer a sobering countervision to the euphoric deception of his sales pitches. While the latter uphold the illusion of a happiness and satisfaction that Don knows can never be obtained, these spectral visions offer him a self-knowledge which he cannot afford not to acknowledge. As such, they allow him to confront all the dark aspects of his existence in preparation for the moment when he will be able to openly share this painful and embarrassing truth with others. And finally, with regard to cinematic language itself, this spectral memory work also scenically puts on display the toxic underbelly of Don's inspired sales pitches. Similar to the way Andy Warhol confronts his serial images of glamour stars with his disaster images, so as to disclose the two sides of an American obsession with commodified celebrity, so, too, Don's hallucinations offer an insight into the fragility of the imagined scenes of happy childhood, which, to his clients, he claims to be his own memories.

In the last season of *Mad Men*, while Don is once more driving westward in an effort to flee the constraints of his new

position at McCann Erickson, the ghost of the deceased Bert Cooper appears to him. As always astute in his assessment of the situation, he accuses his former partner: "You like to play the stranger." Then he proceeds to elevate to a national American character trait the wish to abdicate responsibility and withdraw from a commitment to the ordinary everyday. Even though Bert claims not to have read Kerouac, he can nevertheless quote the iconic passage from *On the Road*: "Wither goest thou, America, in thy shiny car in the night" (MM 7.12). Shortly afterwards, Don has his last nightmare vision, and this, also, involves a nocturnal car trip. As though his dream work were explicitly tapping into the 1960s TV series *The Fugitive*, a policeman stops his car and asks to see his driver's license. While he holds the beam of his flashlight directly into Don's face, the cop assures him: "We've been looking for you. You knew we'd catch up with you eventually" (MM 7.13). Taken together, these two spectral scenes once more disclose (or undrape) what lies at the core of Don's psychic ambivalence. On the one hand, he is driven by the desire to free himself of his ties to others, whenever these seem to encumber him, which also means claiming the right for himself to abnegate his responsibility towards others. On the other hand, he is equally driven by the wish to finally put an end to his perpetual existential flight from the demands of others. Throughout *Mad Men*, Don is shown to harbor one seemingly insurmountable anxiety that persistently overshadows his charismatic self-confidence, namely that the identity theft he is guilty of may be discovered and the law might catch up with him. These last two spectral visions, in turn, offer him an answer to this psychic quandary. He

must own up to his past, must confess what lies at the source of his deception, even if no one is interested in listening, and even if this disclosure has no consequences except for himself.

In the final episodes of the show, he will, in two separate instances, relate what happened to him in Korea, without, however, divulging everything that we were shown during his daydream in the first season of *Mad Men*. While binge drinking with a bunch of brethren war veterans, he finally confesses: "I killed my C.O. We were under fire, fuel was everywhere and I dropped my lighter and I blew him apart, and I got to go home" (MM 7.12). They do not reproach him. To them, all is fair in war, when what is at issue is the safe return home of a fellow G.I. Then, having finally arrived at the Esalen Institute on the West Coast, and thus at the furthest edge of the American continent, he makes a person-to-person call to Peggy, during which he tearfully confesses: "I messed everything up. I'm not the man you think I am... I took another man's name and made nothing of it" (MM 7.13). While Don had always been afraid of being court-martialed for desertion, the fact that he does not worry about an indictment for manslaughter also indicates the following: Even if he feels quiet remorse for what happened in Korea, he does not feel legally responsible for the death he caused. Furthermore, he is primarily embarrassed about the identity theft not because he took on the name of a dead man, but because he feels that, in retrospect, he did not fully exploit this fortuitous chance, did not make the best he could have of this opportunity. In other words, he is perturbed less by the many deaths which accompany his series of second chances—a list that begins with the young prostitute who gave birth to him,

and which ends with Bert Cooper, the man who, throughout the show, has represented a reliable paternal authority. Instead, what bothers him are the consequences of the radical individualism that Emerson subsumes under the notion of self-reliance. If one can gain self-knowledge only by fully trusting in oneself, then this knowledge is only *of* and *for* oneself. It is not—yet—knowledge imparted or shared.

Even though neither of these two confessions will have any repercussions, Don's self-accusations prepare for the dramaturgic *peripeteia*, which will lead to a new beginning. A final analogy emerges between, on the one hand, the ecstatic visions that make Don such a persuasive ad man precisely because they allow him to tap into the desires of others and transform these into forceful visual stories, and, on the other hand, his uncanny spectral visions that make him a stranger to himself and a stranger in his world. After all, essential to poetic genius, according to Emerson, are the poet's eyes, given that they allow him to integrate the many disparate and fragmentary impressions into a coherent whole. Yet this unique gift goes in tandem with a loss of self, which, in the act of inspired vision, dissolves into the transcendental spirit: "I become a transparent eye-ball; I am nothing; I see all; the currents of the Universal Being circulate through me."[41] The hallucinatory visions in which Don's current self, rather than sounding out the desires of others, merges with impressions from his own past, thus emerge as the counterpart to his creative genius, and as such also to the promise of happiness and possibility that he is so successful in selling to others.

While Don Draper's audacious confidence game begins with the involuntary killing of his commanding officer—an act that not only allows him to become a charismatic star on Madison Avenue but also compels him to traverse his personal Hades –, it ends with the embrace of a stranger. After his person-to-person phone conversation with Peggy, which forced him to openly confront the empty solitude around which all of his efforts and endeavors have been revolving, he has literally hit rock bottom. Having assured her that he had simply wanted to hear her voice once more, he abruptly hangs up because he can no longer stand upright. Overcome by a paralyzing anxiety, he cowers beneath the telephone box, unable to move. Only once one of the therapists, who, having noticed his pain, invites him to join her seminar, can he slowly straighten himself up again.

The decisive reversal, however, which will open up yet another second chance for him, requires the confession of another person. During the group therapy, Don recognizes in the words of one of the other guests at the Esalen Institute his own, tenaciously suppressed thoughts—and this recognition also belongs to Emerson's notion of self-reliance. Only in the other man's divulgence of his unbearable solitude does a recognition of his own isolation come back to Don with a certain alienated majesty. Leonard (Evan Arnold) also speaks about an unsatisfiable desire, but for him it is not about a nebulous promise of happiness, still to be attained. Instead, he begins his public confession by describing how neither his co-workers nor his family take much notice of him, indeed hardly acknowledge his presence. Initially, he cannot even find words that might adequately describe what he feels to be lacking in his life. Then he, too,

offers a dream scene to represent his quiet despair. While the rest of his family is sitting in the kitchen, blithely eating their dinner, he is on a shelf in the dark interior of the refrigerator: "And then somebody opens the door. And you see them smiling, and they're happy to see you, but maybe they don't look right at you and maybe they don't pick you. And then the door closes again, the light goes off" (MM 7.14).

These words, finally, allow Don to wake up from his own desperate seclusion, walk toward the crying man and fervently embrace him, while all the others present watch in bemused silence. In this gesture, his own embarrassing outburst of tears during the Hershey's sales pitch finds its narrative closure. The *peripeteia* of the scene offers up the following argument: Because he is prepared to recognize the pain of the other man, he can also accept his own pain. Mirroring himself in the other man's pain is tantamount to the pivotal self-manifestation of his own pain. This gesture of empathy allows him to acknowledge his own separateness. At the same time, it permits an authentic encounter with another person, beyond all narcissistic projections, and thus also apart from any sentimental self-affirmation. Abandoning himself to the pain of the other is also an expression of self-forgiveness.

One last time, the logic of being given a second chance comes into its own. In order to find himself again, to recover his life, Don must relinquish everything; he must accept his own complete abandonment. In the embrace with the stranger, in whose words he recognizes his own thoughts, he can embrace his own nothingness, accept the void at the kernel of all his self-fashionings. Even if only for a brief moment, he breaks

out of the imprisonment of his solitude. Only now is he emotionally equipped to walk into the dusk, from which a new day can emerge. Stanley Cavell calls this moment of recovery "the transfiguration of *mourning* as grief into *morning* as dawning and ecstasy."[42] It proposes, as Cavell explains, a regaining of the world in the knowledge of loss. For Don, neither remorse nor redemption follows upon this self-recognition. If his destructive melancholia counteracts his ecstatic trust in the achievability of happiness, without ever pulling him completely into the abyss, then only a new cycle of confidence games can follow upon this wordless confession. His future will continue to be predicated on a constant pitching between self-reliance, fallibility and recovery; his creative genius will continue to draw its vitality from a descent into the loneliness of his own heart. As Emerson puts it: "Every ultimate fact is only the first of a new series."[43]

The Elevator—A Heterotopia

515 Madison Avenue door to heaven?

Portal stopped realities and eternal licentiousness or at least the

jungle of impossible eagerness your marble is bronze and your

lianas elevator cables swinging from the myth of ascending

I would join Or declining the challenge of racial attractions

Frank O'Hara

Because his wife and daughter have gone off to Block Island for the Labor Day weekend, Roger, who at the end of the first season of *Mad Men* is still having a clandestine affair with Joan, proposes that the two of them spend the evening together. They could go anywhere, he smugly asserts, even sit at a table at The Colony with their clothes off if they wanted to. Yet the Broadway show he proposes does not tempt Joan. Instead she suggests going to see *The Apartment*, having heard that Shirley MacLaine is supposed to be very good. Roger, who has already seen the film, retorts disparagingly: "A white elevator operator and a girl at that? I want to work at that place" (MM 1.10). Joan had, in fact, only mentioned the film to draw attention to an analogy between her own situation and that of Billy Wilder's heroine, who is also having an affair with her married boss. She is, of course, able to play with Roger's desire far more resourcefully because, as the office manager at Sterling Cooper, she has significantly more power than MacLaine's Fran Kubelik, who is simply allowed to operate the elevator. Yet Roger's cynical reference that casting a white actress in this role makes

the character implausible draws attention to how decisive this site is for Weiner's TV series as a whole. In the office building in which the agency Sterling Cooper is located, only African Americans press the buttons in the elevators. This detail is of dramaturgic importance for the show's narrative argument, given that the coherence of the agency is based on the marginalization of precisely this part of the working population.

Early on in the first season, Paul Kinsey (Michael Gladis) greets the liftboy Hollis (La Monde Byrd) emphatically as he enters the elevator, seeking to demonstrate his lack of racial prejudice. Although Hollis is positioned at the outer edge of the frame, and is thus barely visible, he joins the other young men in their laughter at the ribald comments they are making about Pete's honeymoon. In another scene, Hollis shares his shock at the sudden death of Marilyn Monroe with Peggy and Don as he is conveying them up to their office floor. In response to Peggy's comment that she had never imagined such a famous star ever being alone, he declares: "Some people just hide in plain sight" (MM 2.9). For a brief moment, the framing moves him into the center of the image and the camera tarries with his sad silence, while Don, whom this discussion about suicide has clearly made uncomfortable, has completely disappeared from our field of vision. The spatial constriction of the elevator renders Don's impatience only more tangible, even if it remains open whether his discomfort pertains merely to the theme of their conversation or also to the fact that, unsolicited, this African American employee is obliquely sharing an intimate insight into his own situation with them. At the end of this first season, however, Hollis' co-worker, Sonny, will wrong-

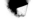

Hollis shares his thoughts on Marilyn Monroe.

fully be fired, because, after Peggy reported a theft that took place in the locker room of the office during the wild election night party, suspicion immediately fell on the African Americans employed there.

For the dirty trick that he plays on Roger in "Red in the Face" (MM 1.7), wishing to punish him for having flirted with Betty, Don, in turn, seeks out the help of this elevator operator. Pete has just gotten out of the elevator where Don is waiting for Hollis. Because Pete has a shotgun flung over his shoulder as he walks briskly to his office, the two men, gazing after him, smile at each other regarding this curious appearance. Then Don gets into the elevator himself. Through the gap of the closing doors we briefly see the dollar bills he is offering as a bribe to Hollis. That afternoon, Hollis will keep the elevator out of service so that, after having lunched with Don, an intoxicated Roger is forced to walk up 23 flights of stairs. In the foyer of their offices, Don is allowed to enjoy his revenge. Having finally

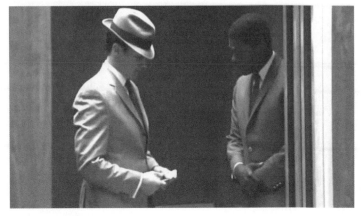

Hollis takes a bribe.

arrived, sweating and out of breath, Roger vomits his opulent meal in front of the delegates from the Nixon campaign.

While Don uses the seclusion of this closed space to concoct his petty intrigue with Hollis, Pete seizes upon this opportunity to try and find out something about the consumer behavior of African Americans. Because he wants to know why Hollis bought an RCA television set and not the brand they are representing, he suddenly stops the elevator between two floors, once the other passengers have gotten out. He aggressively challenges Hollis to an honest conversation, which, owing to the difference in social status between the two men, seems possible only in the extraordinary situation that an elevator, brought to a standstill, offers. Hollis, in turn, perceives this disruption as a threatening transgression of precisely the boundary that normally separates him from his passengers, ascribing to him the role of a semi-invisible audience of their banter. Pressurized, he gives a candid answer, although it is not the one Pete wants

Hollis and Pete on the contradictions of racial inequality.

to hear: "We've got bigger problems to worry about than TV, okay" (MM 3.5). Pete insists on pursuing this conversation, explaining that when it comes to consumer brands, "the idea is that everyone is going to have a house, a car, a television. The American dream." Hollis, however, does not take the pitch and instead, smiling weakly, sets the elevator in motion again. His way of preserving his dignity is to insist on the boundary that, in this work place, relegates him to the silent minority. Precisely because it is such a slight gesture of empowerment, the fact that he can determine when to set the elevator in motion again draws attention to the fact, that for many African Americans, the vision Pete invokes has remained an empty promise, still held in abeyance. They have yet to arrive at the executive suite, which they are only allowed to clean. Hollis, in fact, is only supposed to leave the elevator on the ground floor, to exit the building.

And yet, the intimacy that the employees and partners of Sterling Cooper share with this elevator operator suspends, for the brief period of the ride up and down the floors of this office building, the segregation on which their work environment is based. If, in the first three seasons of *Mad Men*, African Americans only appear in menial jobs, on the periphery of the narrative action, the shared scenes in the elevator anticipate a post-racist world, possible but not yet achieved. At the same time, the exclusion of African Americans from the main activities of the agency comes to be further underscored by virtue of the fact that this contact can take place only in the closed space of an elevator, in motion to boot. Drawing attention to the very limited agency open to African Americans in the advertisement world of Madison Avenue, corresponding as it does to the spatial confinement of this constricted post, pits something against the social prejudices of all those whom they convey from one floor to the next. There is a position external to this office world, which cannot be subsumed into its ordinary everyday routine, and which, instead, takes place parallel to it—namely in the elevator. At the same time, this external point of view, only glimpsed intermittently from the margins, also renders visible how confined the world of white middle and upper class privilege in fact is, even if, at the beginning of *Mad Men*, it is still more or less a self-confident one.

After the third season of the show, there will be no more African American elevator operators. In the Time & Life Building on the Avenue of the Americas, into which the newly founded agency Sterling Cooper Draper Pryce moves, everyone must operate the elevators themselves; even if, to the end, Bert, an

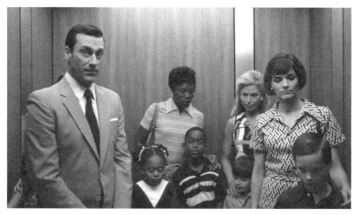

African Americans have moved into the frame of vision.

old school man, cannot bring himself to do this. Shortly before Don and his partners are once more forced to leave these offices, something crucial has actually changed, including the fact that they have begun hiring African American women as secretaries. In the seventh season we see Don standing in the elevator, somewhat bewildered as he gazes at the bevy of children surrounding him. Among them are two African American kids with their mother. They, too, have been invited to the agency to serve as a focus group for a new toy. Now Don is the one to stand guard as the elevator door opens, cautiously protecting the children as they pass by him before he himself enters the foyer.

In *Mad Men*, the elevators in general function as the spatial counterpart to outside shots of the office building in which the agency is located. In contrast to the classic office film, however, the camera never pans up and down along these glass façades so as to visualize the connection between the various floors.[44]

Instead, this movement is exclusively undertaken by the elevators, in which, in almost every episode, we see characters being transported up or down the building. In contrast to *The Apartment*, however, what is at issue is less the predominantly erotic exchanges that connect people working on different floors of the office. Rather, the focus is more on the spontaneous meetings that can occur between the different floors and the unexpected possibilities that these open up. It is, for example, in an elevator that Peggy meets Joyce (Zosia Mamet), who is working as an assistant photo editor at *Life* magazine. She will subsequently introduce Peggy to the art scene in Greenwich Village, an experience that will soon after encourage her to slowly disengage herself from the environment of the close-knit ethnic neighborhood in Brooklyn, in which her family lives, and forge a very different social life for herself in Manhattan.

If, then, the elevator, moving as it does between the different floors, connects different social groups as well as offices, which, in the ordinary work routine, would remain neatly severed from each other, the individual scenes that take place there present both a spatial and a temporal condensation. In this mobile space within the larger office space, strangers are not only involuntarily made privy to conversations between the others, more often than not of personal nature, but meetings also occur here that have unexpected consequences. Owing to the confined space, furthermore, the passengers stand so close together that for the duration of the ride, all claim to privacy comes to be suspended. Especially for Don, who desperately tries to hide behind the polished façade of his self-fashioned persona, the social permeability and proximity that the eleva-

tor forces upon him, is disconcerting. For this reason he insists on observing certain rules of courtesy and once even orders another man to take off his hat because a woman has gotten into the elevator with them.

The elevator does not, of course, represent a completely open space, but rather a prominent liminal space, whose area is as limited, as the spatial distance it can travel up and down is clearly predetermined. At the same time, it constitutes a free space not only in that it forges a connection between the different floors and the people located there but also in that it serves to demarcate the boundary between inside and outside. Characters who step into the elevator are neither in the entirely private sphere of their homes nor are they embedded in the rigorously regulated hierarchies of the workplace. On this enclosed and yet disengaged stage-within-a-stage they can, thus, speak to each other with impunity, confide in each other, or offer up information that, in the offices of SCDP, they would only divulge behind closed doors. And precisely because these conversations almost always occur with strangers present, even if those speaking to each other are oblivious to their audience, the communication exchanged takes on a performative quality; it becomes an action of sorts. In the elevator, the stage is set for things still to be carried out or followed through in the workplace, as it is also the place where people react to and comment on the nasty power struggles that took place shortly before in the office. Indeed, the elevator often emerges as the site for decision-making, given that the journey between entering the building and arriving at the office often also signifies a passage in a figural sense. As such, the elevator represents a

counter-site, along the lines of what Michel Foucault has called a heterotopia: "actually realized utopias in which the real emplacements that can be found within the culture are, at the same time, represented, contested, and reversed, sorts of places that are outside all places, although they are actually localizable."[45]

As an actual and at the same time operative place, which, in the sense of a counter-site is inscribed into the ordinary workplace, the elevator in *Mad Men* offers space for critical comments on the ugly power structures pertaining particularly to the discrimination of women in the advertisement agencies on Madison Avenue. In the very first episode of *Mad Men*, Peggy is introduced to us as she takes the elevator up on her first day of work. While standing there, she is forced to stoically bear the sexist comments that Ken (Aaron Staton) is making about her to his work buddies. When, upon leaving the elevator, the young men realize that they have been speaking about a new secretary working on their floor, Ken defends his impudent behavior by explaining that it can only be to her advantage to know what to expect from her new job. And even as late as season seven, Michael Ginsberg (Ben Feldman) and Stan Rizzo (Jay R. Ferguson) will make fun of Peggy while accompanying her in the elevator, because she has no date on Valentine's day. The elevator thus consistently serves as a stage to render visible that because she tenaciously refuses the role of the obliging woman who privileges her work over her private life, Peggy remains the object of masculinist ridicule despite her professional success.

It is also on this stage-within-a-stage that the irreconcilable contradictions between personal ambition and romance that those women who want to pursue their American dream in the

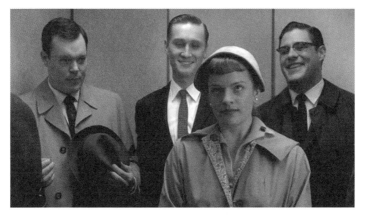

Peggy's first day: Object of sexist banter.

world of advertising face can be obliquely addressed. In the poignant final tableau of "The Beautiful Girls" (MM 4.9), we see the psychologist Dr. Faye Miller (Cara Buono) standing next to Peggy and Joan in the elevator at the end of a work day during which each one of them was confronted with a romantic dilemma. Faye has been forced to realize that she can only stay with Don if she is willing to take on the role of surrogate mother to his children, at the expense of her own career. Joan has had to make it perfectly clear to Roger that although they had a sexual encounter the night before, because they are both married, they cannot renew their affair once more. And Peggy begins to harbor doubts about her relation with Abe Drexler (Charlie Hofheimer) because his radical politics are diametrically opposed to her vision of herself as a future creative director on Madison Avenue. Joan is already standing pensively in the elevator, next to a clearly devastated Faye, when Peggy arrives, asking them to wait for her. As she enters, greeting them, both

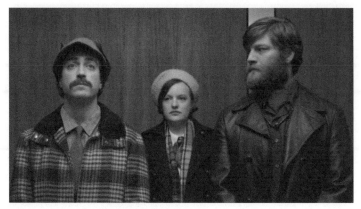

Peggy is bullied on Valentine's Day by her buddies.

are forced to regain their composure. Then, for a few seconds, with Peggy standing in between the two other women, the camera slowly moves forward. Each one is lost in thought, realizing that they are at some turning point in their lives, compelled to make a painful yet necessary decision. Though, as professional women, they have a common predicament, they do not speak to each other. Suspended between work and leisure, each is caught in her own solitude. The choice each one knows she will have to make is one she cannot share with the other two women. It is the price of their self-reliance. And yet, despite their emotional agitation, each holds her elegant pose, standing perfectly upright and looking forward as the elevator doors slowly close in front of them. Because Peggy is standing in the middle, we catch a final glimpse of her through the open gap just before the doors close completely. The trace of a smile seems to be flickering across her face. Like the other two women, she is determined to keep moving.

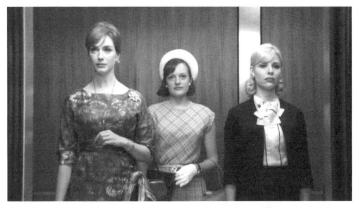

Sustaining the antagonism between romance and personal ambition.

If, then, the elevator consistently serves as the site for articulating the gender trouble that reflects the arduous battle for recognition that, to the end, both Joan and Peggy cannot fully win, it is here, also, that two seminal conversations between the two women take place. Both serve to cruelly illustrate the impossibility of making the right decision because, as professional women trying to move up to the executive floors on Madison Avenue, they repeatedly find themselves in a situation that confronts them with a false choice. During the first of these two conversations, Peggy is reprimanded by Joan as they are taking the elevator down at the end of a particularly difficult day at the office. Peggy has just fired the young copy writer, Joey (Matt Long), because of the pornographic caricature he made of Joan and taped to her window. Peggy thinks that in so doing she has successfully defended her colleague, while Joan reads this as a patronizing gesture of self-assertion, through which both have only lost esteem in the eyes of the men. As she tauntingly

Peggy's quiet self-reliance.

explains: "No matter how powerful we get around here, they can still just draw a cartoon. So all you've done is prove to them that I'm a meaningless secretary and you're another humorless bitch" (MM 4.8).

The two women cannot come up with a resolution to the gendered conflict they are compelled to engage with daily in the offices of the agency. In this counter-site, they can only voice the conflictedness of their defense strategy. Joan is as justified in having recourse to her erotic charm as Peggy is in defending herself against sexual insults by the young men working on her team. And yet, both are also subjected to the tacit codes of a masculinist (and paternalistic) system that remains disrespectful to them. What is, in turn, effectively contested here is the sexism rampant in the agency. In contrast to the romantic dilemmas they cannot share with Dr. Miller, Joan and Peggy are able to openly articulate their conflicting interpretation of how best to respond to Joey's insubordination. At the end of the journey

Joan and Peggy disagree on how to deal with sexism in the business world.

down, furthermore, the difference in attitude between them remains unresolved in a productive sense. What has emerged in the heterotopia of the elevator is the recognition of the process they are involved in. Although there is, as yet, no way of settling the gender trouble they pose as professional women, they are at least aware of the aporia of their position.

The second conversation Joan and Peggy have in an elevator also reflects and contests the condescension shown to them by their colleagues. Although at this point in the show we are in the late 1960s, they still have not gained any adequate recognition in an advertisement world that is still dominated by men. After a meeting at McCann Erickson, during which Joan had been forced to repeatedly bear degrading remarks regarding her breasts, she uses the ride down to assure her sister in arms: "I want to burn this place down" (MM 7.8). Although Peggy is quick to voice her sympathy, her understanding bears a trace of critique. Because she wants to succeed at all costs as a copy

editor on Madison Avenue, hoping one day to become creative director herself, she is also willing to put up with certain insulting behavior, especially when she realizes that it cannot be avoided. Now she is the one to reprimand Joan, telling her that, given the way she dresses, she has to expect such remarks. In so doing, Peggy shows herself to be caught up in the very prejudices that also injure her as a professional woman. Yet what is also rendered visible is that she has no choice other than coming to terms with this lack of acknowledgement. Joan, in turn, can afford not to make any concessions regarding her self-fashioning and refuse to compromise herself, given that, as one of the partners of SC&P, she made an enormous profit when the agency was sold to McCann Erickson. Once again, the elevator serves as the stage for a moment of self-recognition. As professional women in the advertisement business, both can only make a false choice. Neither strategically accommodating prejudices nor idiosyncratically resisting these will result in their being taken seriously. Puzzled, Peggy continues to gaze at Joan, who, having arrived at the ground level, simply leaves the elevator without saying a word. And yet, the disagreement they were able to address in the elevator also anticipates the two different paths they will ultimately take: Peggy's patient perseverance at McCann Erickson and Joan's radical break with this company, choosing instead to found a business of her own.

Equally critically contested in this heterotopic counter-site are the power struggles that the men themselves are involved in, sometimes even leading to bloody fist fights amongst them. Then again Pete and Ken can admit their rivalry with benevolent condescension in the elevator. Here, Pete can boast to the

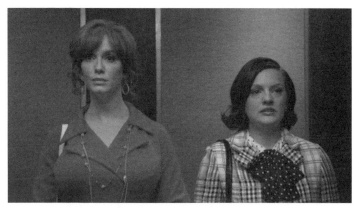

Gaining recognition: Tricky business for professional women.

older partners about a contact he has at the New York Times while they mock his brazen careerism. Here, Michael Ginsberg can hurl his acerbic wit against his boss, furious at Don because he only presented his own ideas at a sales pitch for an ice cream brand. And, moving between the floors of the Time & Life building, the Machiavellian Jim Cutler (Harry Hamlin) can assure his fellow senior executive manager, Roger, that he does not want to have him as his adversary, even while he has already long since set in motion a ploy by which he hopes to take over the agency completely. Rendered visible in these brief dialogues, which usually end in stubborn silence, is that an all-encompassing will to power regulates the relationship between fathers and sons as much as it does the one among peers. As Roger, also in an elevator, once assures Peggy: "It's every man for himself" (MM 5.9). Yet the fact that the show's characters can openly express their anger, their rivalry and their despair in precisely this mobile intermediary zone, and here contest the

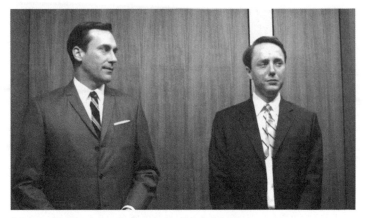

A fight in the office leaves Don to witness Pete's despair.

lacking equity of treatment rampant in the agency, allows for a utopian moment to flicker up, if only for the short period of time it takes for the journey between the floors. The critical comments that are allowed to be made here with impunity give a sense of how this workplace could be perfected.

As Simon Frisch and Christiane Voss have argued, in cinema the elevator in general provides an aesthetically shaped social order, signifying a temporary concentration on a clearly circumscribed narrative situation. As such, it often emerges as the site where both happiness and suffering are initiated.[46] If scenes that take place in an elevator in *Mad Men*, thus, often either initiate or put closure on a narrative sequence, the combination of movement and waiting specific to this site also serves a specific thematic function. In the elevator an action, a decision or an insight is temporarily suspended; it is put on hold so to speak. The moments of transition that are dramaturgically accentuated with each ride are as promising as they are potentially

dangerous. They make up risky moments in the narrative that not only mirror conflicts in the careers as well as the romantic lives of those concerned, but also anticipate crises that could end in a fatal crash. Sometimes the question of transition simply pertains to an ominous accident, such as when Don happens to meet a former lover in an elevator in the Time & Life building, thereby arousing Megan's jealousy.[47] This small disturbance in their romantic happiness foreshadows the end of this marriage as well. Then again, the seclusion of the elevator can prevent a crisis that is about to set in. In "Hands and Knees" (MM 4.10) Don waves away another passenger, signaling to him to take a different elevator, after he has gotten in with Pete. He needs this seclusion to conduct a private conversation. In order to get the security clearance necessary for their agency to represent North American Aviation, he had blindly signed the government form asking about his personal data. Because he is now afraid that the Department of Defense, while doing his backup check, will discover the identity theft he committed in Korea and court-martial him for desertion, he wants Pete to speak to a friend he has in the government. Restricted to the small area of the elevator, which corresponds to Don's premonition that the law may soon corner him, he is able to convince Pete of his fateful position. The latter will agree to give up this lucrative client, just in time to prevent a disaster, looming on the horizon, from taking place.

An even more strikingly risky moment, which for Don anticipates both a personal and a professional crisis, occurs at the open door of an elevator in the fifth season. After Megan has confessed to him that she wants to stop working at the agency

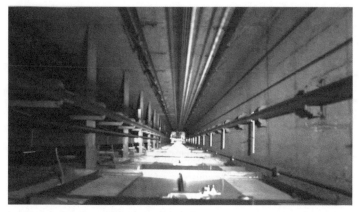

Looking into the abyss: An open elevator shaft.

so as to fully concentrate on her acting career, he accompanies her to the elevator, where he takes leave of her by demonstratively giving her a passionate kiss before the door closes. Then, as though this were an afterthought, he once more presses the button. Although, almost immediately, the doors of the elevator next to the one that Megan just stepped into begin to open, he suspects that something is wrong. Standing on the threshold of the opening, he finds himself looking down into the dark abyss of the empty elevator shaft. More astonished than alarmed, he steps back. Then the doors close again. The concrete danger he was able to avert allows him to recognize how fragile his current living situation, including his marriage with Megan, is. In the following episodes, we see Don begin his downward spiral into acute alcoholism that will ultimately lead to his concrete fall from the grace of his fellow partners, and with it, once more, to a scene at an elevator. On the morning after his embarrassing Hershey's sales pitch, the other partners inform Don that he

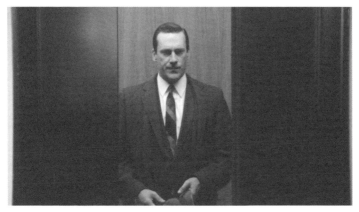

Going down.

is to take a vacation without a return date. 'Duck' Phillips has arrived early with the man who is meant to replace him, so that the two meet in the foyer. Cynically, his rival, Lou Avery (Allan Havey), asks Don whether he is going down, and even presses the button to call back the elevator for him. Then, we see Don standing inside the elevator alone as the doors close in front of his dispirited gaze.

The amazing second chance he gets, several months later, to return to the agency, is, in turn, also introduced with a ride in an elevator. This time we are with him in the moving vehicle as he rides up to the offices of SC&P. Initially we see only his back. Then, in the reverse shot, we are shown the gaze of uncertain anticipation flickering across his face, before the ding-sound of the elevator announces his arrival. The doors open like a curtain; then he walks, confident though cautious, across the threshold. At the beginning of the seventh season everything is, again, possible.

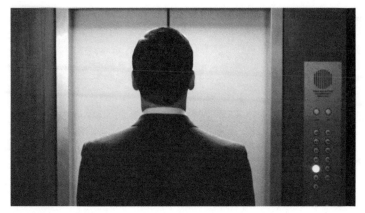

Don arriving again.

The elevator comes to mark the passage from misfortune to good luck. Corresponding to its restricted path of movement up and down the office building, this counter-site signifies that even for those fortunate enough to have access to the executive offices, mobility upwards is limited. But precisely because these elevators are shown to go down no further than the ground floor, they also stand for the fact that radical crashes can be averted. The conversations that take place in elevators entail risky narrative moments because they open up opportunities whose outcome is as yet uncertain. The insights that characters are afforded here will have consequences, even if the characters themselves do not quite know which ones yet. And if the combination of movement and standstill so idiosyncratic to the elevator holds something suspended, this also corresponds to the narrative insertions that happen on this small stage-within-a-stage. It is here that we are presented with a serially conceived chain of short vignettes, in which the conversations between

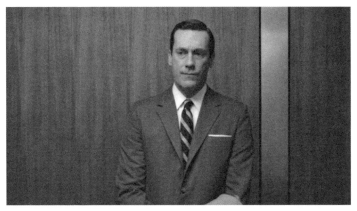

Yet another second chance.

characters raise expectations, disclose something or offer an explanation of something. Performed here, in nuce, is the principle of serial storytelling itself. Whatever is addressed in the elevator responds to a prior occurrence much as, inevitably, it will have an aftereffect.

National Hauntings

The myth of America, if it persists at all, has always rested on a precarious foundation. It is precisely its fragility, not its audacity—the perpetual worry of its believers, not its arrogance—that has made it something different (dare we say better?) than just another version of nationalist pomp.

Jim Cullen

Whenever Roger Sterling wants to remind others of the fact that he was on a destroyer in the Pacific during the Second World War, he usually does so in the form of seemingly jocular remarks. A visit to an elegant restaurant with Don and their respective wives, for example, can quickly induce him to make a witty reference to past wars. In order to get another round of drinks, he asks the waiter, "Tell the lieutenant, please, that things are getting a little dry around Hill 29." He is immensely pleased at Don's clever repartee: "All clear in No Man's Land" (MM 1.2). Like Don, Roger is also haunted by his experiences at the frontline, only he positively boasts about a past that he does not, under any circumstances, want to forget. At the same time, in their shared war experience, these two men are also shown to bond. During a dinner in her own home, Betty asks Roger to tell a true war story and he unhesitatingly describes how his father, with a bayonet in his hand, successfully killed a German soldier who was lying only a few feet away from him in the trenches. Her own husband, in response to Betty's complaint that Don hardly speaks about the war, defends himself

by objecting to his work buddy: "Not much to say, you boys used up all the glory." Roger, in turn, immediately takes up the challenge, and explains: "My old man will always have one on me with that bayonet" (MM 1.7). War memories, however, not only serve to forge an affective connection between the two figural brothers in arms, Roger and Don.[48] War, as the event that different generations of Americans share, also brings to the fore the difficulties the sons have when it comes to measuring up to their fathers. For precisely this reason, Roger proceeds at once to recount the mission for which he was decorated. In his witty rendition, shooting down a Japanese reconnaissance plane transforms into a gleeful adventure in the South China Sea.

That Roger takes these war anecdotes quite seriously, however, becomes clear as well in the first season. After his heart attack, Roger confesses to Don, "I've been living the last 20 years like I'm on shore leave" (MM 1.10). If the trope he comes up with for his fear of death is the idea of returning to the war front, then that means he has been treating his life during peace times as a time-out from war. His untroubled insistence that, for him at least, the Second World War is as yet unfinished business is only consistent. His persistent jokes about military matters thus prove to be the flip side of his own quiet melancholy. Like Don, he, too, lives in two temporal periods. His past life as a soldier, which he had to leave behind on the Pacific front upon returning home from war, obliquely overshadows his current work on Madison Avenue. And he, too, is estranged from his fellow men and women owing to this double life. Once, on December 9th, he arrives at the office ostentatiously wearing a

colorful Hawaiian shirt over his elegant vest to celebrate Pearl Harbor Day. Already inebriated, he proceeds to explain to one of the secretaries why, even though this attack was a stroke of genius, it ultimately brought about the defeat of the Japanese enemy. Nobody, however, is much interested in what he has to say, given that for most of the others, the political situation has drastically changed. While his war memories serve as the decisive point of orientation for his thinking, his insistence on reminding others about the human loss this war entailed blights the confident optimism they prefer to place in the future.

Nowhere does his refusal to consign the Second World War to the past cause as much conflict between him and his partners as in their competition for the Honda account. During the meeting at which Pete informs the others about this amazing opportunity, Roger insists that their agency will not do business with the Japanese. "I used to be a man with a lot of friends," he asserts, "then World War II came and they were all killed by your new yellow buddies." Bert, who keeps his war record to himself, resolutely retorts: "The war is over, Roger" (MM 4.5). This does not, however, prevent his recalcitrant partner from attending the meeting with the representatives of the Japanese car company, during which he immediately proceeds to embarrass them by recasting the conditions they have proposed for the competition in terms of a continuation of war with other means.[49] Showing loyalty toward the dead is more important to Roger than any form of reconciliation. Given that he obstinately insists that he made an oath to his war comrades that must not be broken, he can only conceive of Don's decision to nevertheless give a sales pitch to the Honda representatives as

a sign of capitulation. Joan, to whom he turns in the hope of finding solace, sternly rebukes his self-pity. "Roger, I know it was awful and I know it will never seem like it was that long ago," she explains, "but you fought to make the world a safer place and you won and now it is" (MM 4.5). At stake are two different attitudes. While Joan feels compelled to give her attention to the real threats posed by a war taking place in South-East Asia at the time of their conversation, Roger insists on not letting current events screen out the past war, because he does not want to let go of those who fought and died in it.

Both are right in their own way. Joan, whose husband is about to be deployed in Vietnam, needs to adjust to the situation of becoming a single mother. When she discovers barely a year later that he has volunteered to do another tour there as an army surgeon, she throws her husband out of her life completely. Even though he defends himself, accusing her that she would have praised his decision if it were the Second World War and the Japanese had attacked America, she refuses to change her attitude. Unaffected by his military passion, she retaliates by insisting that, then as now, soldiers wanted to come home and stay there. As a professional woman who on a daily basis must deal with the sexist attacks on her own work front, she is immune to all sentimental war patriotism. Roger, in turn, has never fully returned home from the war in the Pacific. He openly laments the fact that he has no friends from before he enlisted. "The Sword and the Chrysanthemum" (MM 4.5) also draws our attention to the fact that the site of martial conflict has, to a degree, begun to surface within the nation as well. Significantly, the backdrop for Roger's aggressive contestation of

his agency's dealings with Honda are news images from Selma, Alabama, where a protest march against the obstruction of African American voters calls forth open violence. It may be that the world has changed, but the deployment of violence as a political weapon has remained the same. Only for some has America really become a safer place.

How tenaciously Roger is influenced by his experiences on the destroyer in the Pacific is also revealed in the fact that, to the end, he uses these recollections to gauge his current situation. After his agency has been swallowed by the behemoth, McCann Erickson, and they are forced to leave the offices in the Time & Life building, he recounts one last true war story. Standing forlornly in the empty foyer of what was once the executive suite, he takes Peggy into his confidence. To her, the sale of the agency seems like a challenging opportunity, even if this was something imposed on them. Roger, in turn, invokes a scene from the summer of 1944 in order to explain his take on the unexpected change of fortune that has beset him. It had been a very hot day and his captain therefore decided to anchor in a Laguna so that everyone could go swimming. Initially he was not able to follow his comrades, who had immediately jumped into the water. The ship was two storeys high and he had been afraid to dive down that deep. Whimsically he admits that he ultimately did jump, but only because someone had pushed him. His gaze at the abandoned offices allows him to link the two sites in his mind, assuring Peggy: "This was a hell of a boat" (7.12). Yet this assertion implicitly calls up another trope. While Jim Hobart, Chief Executive at McCann Erickson, confessed to Don Draper in the same episode that he

was the white whale he had been chasing for ten years, Roger's comment also makes reference to the novel *Moby-Dick*, albeit obliquely. His advertisement agency is comparable to Captain Ahab's ship named *Pequod*, which, in his novel, Herman Melville conceived as a miniature of the American nation. In *Mad Men*, this "hell of a boat" also serves as the stage where the struggles so characteristic of the 1960s—between the generations, the sexes and diverse ethnic minorities—have come to be played out; in proxy for American society at large.

Yet Roger is not the only one haunted by war. Even if not as consistently, other characters are also associated with their military past so as to render visible the continuation of war with other means in civilian life. Sometimes this serves to explain why a character such as 'Duck' Phillips repeatedly fails in the business world. At one point, trying to convince Don to help him out of a tough spot, he admits that during his time with the Marine Corps he once was negligent while on duty and had needed his comrades to cover for him. The break he asks Don for is meant to assuage this embarrassment. Then again, a laconic reference to the war can also explain the tough resilience of a character such as the Machiavellian Jim Cutler, who proudly confesses to his melancholic partner, Ted Chaough, that during his bomb raids over Dresden he felt no death wish (and thus, implicitly, no subsequent compunction either). Other scenes are less about personal memories than a commemoration of those who fought for the American nation in the past. Pete Campbell shamelessly uses the legend of a great-grandaunt, who is supposed to have valiantly attacked a Hessian officer during the American Revolution, when he wants to impress his landowner with his pres-

tigious pedigree. And in the conversation Lee Garner Jr. has with Roger in a bar, so as to inform him that the Lucky Strike account has been given to another agency, he, too, has recourse to a family legend. Lee Garner Jr. recalls that at the end of the Civil War, his grandfather had refused to capitulate and instead chose to re-encode even this terrible defeat as a moment of celebration, hoping that Roger will do the same.

Don himself is fairly reticent when it comes to paying homage to the past. During a 4th of July party, which he is celebrating together with Betty and his children at their country club, the MC asks all the war veterans to stand up. The applause they receive is meant as a sign of recognition from all those present for the courage they showed serving their country. Because the situation is embarrassing to Don, he initially hesitates getting up from his chair. But seeing his daughter, Sally (Kiernan Shipka), wildly clapping, he finally stands up as well, bemused at her pride. While he feels uncomfortable because he knows that he does not deserve this accolade, the ironic distance he brings to this scene also exposes the protective function of this staged military commemoration. The oldest veteran present, who is, in fact, called out by name, was a member of the Rough Riders, the cavalry unit in which Theodore Roosevelt himself fought during the Spanish-American War. His presence, token of the survival of a former national spirit, however, also obliquely references the botched invasion of the Bay of Pigs. This recent event can precisely not be taken as an example for the heroic valor of American troops. Cuba in the 1960s emerges instead as the site of a military defeat that actually came to encourage rather than abate a real nuclear threat to the nation.

In his own home, Don resolutely undermines all romantic war worship. One evening, soon after Betty's father, Gene (Ryan Cutrona), who is suffering from dementia, has moved in with them, Don watches him unpack his war memorabilia in their kitchen. First, casting a mischievous glance at his son-in-law, Gene shows him the Victory Medal he earned for his valorous deeds in the trenches of northern France. Then, pulling a Prussian helmet from one of the cardboard boxes, he directs the attention of his grandson to the holes that indicate where he shot his enemy, with dried blood still clinging to the edges. After he proceeds to proudly place this trophy on Bobby's (Maxwell Huckabee) head, Don, who up to this point had watched in silence, intervenes. Explaining to his son that this hat belongs to a dead man, he once more removes the helmet and puts it away. While Don opposes all glorification of war, because it so fundamentally contradicts his own experience in Korea, for his father-in-law, his time in the trenches during WWI is precisely his most lasting memory, indeed one of the few he has managed to retain. He may have lost his short-term memory, but recollections of his camaraderie with the other doughboys, which, he insists, was what made him a man, resiliently remain with him. *Mad Men* thus makes use of personalized war remembrances, regardless whether they cannot or must not be forgotten, to negotiate the collective haunting of the nation. These war stories make up a shared cultural space that includes everyone, even while it also constitutes a consecutive series. If the founding of America was predicated on a war of independence, its subsequent history, punctuated as it is with further wars, finds, in the 1960s, a logical continuation of this violent struggle for

self-definition in the war in South-East Asia. The notion of historical re-imagination negotiated in *Mad Men* thus also speaks to the repetition compulsion inscribed in America's military interventions.

A continuation of war in peacetime, however, also surfaces in the way that military jargon (and indeed military codes of conduct) not only informs the work environment at Sterling Cooper, but also helps shape the competition amongst the agencies on Madison Avenue. Early on in *Mad Men*, Pete, seeking to ingratiate himself with Don, raves: "A man like you I'd follow into combat blindfolded and I wouldn't be the first. Am I right buddy?" (MM 1.1). Don contemptuously repudiates such camaraderie from a junior colleague so unscrupulously seeking self-advancement. A few episodes later, however, Roger will himself once again invoke the notion of the military's chain of command, so as to make Pete pledge his loyalty to the senior creative director of whom, at this point in the show, he is deeply envious. "I know your generation went to college instead of serving, so I'll illuminate you," Roger explains: "This man is your commanding officer. You live and die in his shadow" (MM 1.4). Indeed, the verbal wit of the dialogs in *Mad Men* frequently borrows from military vocabulary. The office employees are often called 'troops' by their superiors, an impasse is quickly compared to Chamberlain's 'Munich agreement,' while Bert Cooper does not hesitate to speak of the merger with the British firm Putnam, Powell & Lowe as "life under British rule" (MM 3.1). Then, again, Freddy Rumsen (Joel Murray), in a moment of crisis, recalls his time with the Signal Corps during WWII. Forced to explain why he had been too drunk to

give a sales pitch for Samsonite, he can only admit that it was a SNAFU (*Situation Normal, All Fucked Up*).[50]

The cultural survival of war in the offices of postwar America, which the intermittent recourse to military jargon attests to in *Mad Men*, can be concretely attributed to the incredible logistics involved in the D-Day Landing on Omaha Beach in Normandy on June 6th, 1944. As Christoph Bartmann suggests, the superiority of American management could henceforth draw on precisely this organizational achievement, given that it promised to introduce the principles of a good and just war into the civilian world of business. As he argues, the often still young veterans of the Second World War that now rushed into the big corporations to there prove themselves as they had previously done in battle, wanted, on the one hand, to continue to deploy tested military methods. On the other hand, they were equally eager to further the democratic principles of the free West, which had just recently won a victory over the ideological violence and tyranny of totalitarian governments.[51]

Yet, in *Mad Men*, the sustained militarization of the business world also takes on a cynical note. What is rendered visible is the way energies that previously were mobilized for war can just as readily be brought into play in this new environment. Indeed, in this urban war zone, men are allowed to ruthlessly deploy all means, if necessary, in order to either keep an old client or win a new one. They are even allowed to exercise the destructive furor of battle if this promises financial success and social reputation. To think of their competition with other advertisement agencies in terms of the art of war sweeps away all moral scruples and even justifies betrayal and deceit. In order

to convince Peggy to work for an advertisement campaign for Heinz Ketchup, even though she only found out about this possibility in a private conversation with Stan, who is still working for Don Draper, her new boss, Ted Chaough, asserts: "This is how wars are won." It is not an issue of betraying her friend's confidence, because, as he assures her, if he is working with one of their competitors, "he is the enemy" (MM 6.3).

Military logic, however, is also responsible for the fact that these two rivaling creative directors will ultimately join forces. On the evening of their presentation for Chevy, Don and Ted meet in the bar of their hotel where they realize that they can only succeed if they turn a competition, conceived in terms of war, in their favor. Don had made the claim that the management of General Motors "fight the war with bodies on the ground" (MM 6.6). This trope, borrowed from a discourse about frontline engagement, is meant to support his argument that only an agency large enough to open up another office in Detroit can win this account. The moment Don senses that he can forge an unexpected alliance with his former enemy, his reference to a continuation of war even takes on a playful note. Fired on by his own military pitch, he asks his new brother in arms, pointing to the bar, "Hey, Lieutenant, want to get into some trouble?" Ted, himself inspired by this newly aroused lust for battle, agrees. The merger of the two small agencies under the name SC&P will, indeed, amount to a peace treaty, given that they now no longer need to fight each other in public. The critical light *Mad Men* sheds on a continuation of military strategies in the American business world is, however, such that after this merger, Jim Cutler, who had been head of accounts

139

at CGC, instigates an internal battle. The conflict between media and creative, which Don had already won after their first merger with the British firm PP&L, is merely a pretext. That Cutler, in order to install an enormous mainframe computer, sacrifices the lounge of Don's creative team, which had, in fact, made the agency so special in their eyes, also gestures towards a political development. The competition Cutler fuels amongst the different agencies on Madison Avenue regarding who has the best data processing facilities implicitly corresponds to the arms race between the superpowers during the Cold War. Don's creative department threatens to become the internal collateral damage of this proxy war.

Once again Ted is the one to openly address this continuation of war in their workplace. If, before the merger, he was the one who declared all those working for his competitors to be his enemies, he now reproaches his old partner for thinking in military terms, given that it now concerns their own agency: "You're splitting this place and not in half" (MM 7.2). Jim Cutler's concept of management is precisely not predicated on democratic principles, but rather on a form of absolute sovereignty merely adapted to new Western technologies. He is willing to tolerate neither Don's unpredictable behavior nor Roger's recklessness because both introduce a contingency factor into what he sees as his efforts at optimizing the course of business. In the end, it is the American spirit of democracy, however, that will win the day. During their last conversation, the old patriarch Bert gives a crucial piece of advice to his long-time partner Roger regarding how best to battle an internal enemy. Outlining for Roger what options are open to them if

they want to hold together their side of the agency, he casts everything in terms of the pathos of war camaraderie. Jim Cutler may have a vision, Bert explains, but he is not part of his team, and to it any good leader must remain loyal at all costs. While he concedes that Roger, in turn, has both skill and experience, in Bert's eyes he is not a leader. When, after Bert's death, the difference between him and Cutler comes to a head, Roger will actually discover a loophole in this alleged aporia, allowing him to turn the conflict to his advantage. After all the partners have agreed on the merger with McCann Erickson, even if they need only commit themselves to a three-year contract, he emerges as the victorious leader of his troops. Cutler, forced to abdicate, will ultimately ask to be bought out and, in so doing, leave this theater of battle completely.

War in *Mad Men* thus emerges as unfinished business in a double sense, even while reflecting upon the historical moment in which it was itself produced. On the one hand, the violent events of the Cold War make up the backdrop for a conception of the business world that remains heavily influenced by military logic. In Weiner's historical re-imagination of the Madison Avenue of the 1960s, the key players and their competitors think and act in terms of comrades, willing to sacrifice everything in their competition with adversaries whom they target as enemies. On the other hand, equally significant is the way that allusions to past wars are shown to correspond to news broadcasts, reporting about actual international and national conflicts in the present: most notably the Cuban Missile Crisis, the war in Vietnam, as well as the political power struggles around the Civil Rights Movement, erupting in street violence

but also leading to the assassination of John F. Kennedy, Bobby Kennedy and Dr. Martin Luther King.

If Weiner's *Mad Men* repeatedly falls back on tropes and idioms borrowed from the language of war, then perhaps because it seeks to underscore a particular continuity of military thinking in the history lesson it has to offer. America, which the agency SC&P represents in miniature, has incessantly defined itself as a nation by virtue of military interventions, in both its foreign and its domestic policies, and it continues to do so today. The deployment of military concepts, however, also demonstrates how the world of business that, at the beginning of this TV show, is still predominantly white, male and upper middle class, is compelled to adapt itself to the cultural changes of the times. In the course of the series even the African American secretary, Dawn (Teyonah Parris), along with Peggy and Joan, is able to rise up in the hierarchy and get an office of her own; a privilege previously open only to men. At the same time, the financial situation of the agency, which becomes ever more precarious after the fourth season, can be read as a reflection on the impending military defeat in South-East Asia. The declining trajectory of the 'boat' bearing the name Sterling and Cooper runs analogous to the war in Vietnam. The empty offices of SC&P, in which Roger tells his last true war story to Peggy, uncannily anticipate the evacuation of the American embassy in Saigon only a few years later.

Significantly, the actual impact of the Cold War is primarily brought into play in *Mad Men* by virtue of its media transmission. While we only rarely see characters in locations that are directly affected by the political events of the time, news about

these occurrences permeate the apparent safety of their every-day lives and interrupt their daily business in the form of ar-ticles in the *New York Times* or broadcasts on the radio and on TV. Repeatedly, montage sequences make use of documentary footage, reminding us how, at the time, the political crises of the 1960s were broadcast. In so doing, these re-invoked news broadcasts not only resuscitate the past for us but also serve as the invisible cord connecting the various characters with each other. If the montage technique splices together documentary evidence with fictional re-imagination, it also welds together the past and the present. As representations of real events, these TV news broadcasts constitute an affectively forceful counterpart to all those stories about happiness and prosper-ity that Don and his team come up with as their advertisement strategies. As Michael Wood argues in general for the myths commercial media creates, "the solution has to be imaginary because the dilemma is authentic—if there were a real solu-tion, the myth wouldn't be needed."[52]

By interlinking these two visual series, *Mad Men*, however, also self-consciously refers to the fact that, on American televi-sion in the 1960s, commercials and news shows would already seamlessly flow into each other. On the level of their media transmission, these two very different ways of representing the present as a visual narrative were always already conceived as two sides of the same coin. The inclusion of TV news broadcasts from the 1960s in *Mad Men*, splicing together documentary re-portage with studio-filmed fiction, thus brings into play once again a visual logic borrowed from Pop Art. Andy Warhol's point, after all, was that images are real while the real is ever

only graspable through images. Our access to the world—then and now—requires a formalized representation. The historic 1960s news images of political violence do not simply interrupt the everyday lives of the fictional characters of Weiner's TV show. They also render visible the real social antagonisms that advertisement, with its promise of happiness, seeks to resolve on the level of the cultural imaginary. The news broadcasts themselves, however, do so as representations that aesthetically refigure political events even as they offer a moral commentary on them.

The wager of *Mad Men* thus consists in the following: With the help of two separate but parallel visual series—the advertisement stories created by Don Draper together with his team, and the documentary material that serves as evidence of former news broadcasts—a fictional time travel into the 1960s can be undertaken. The real political battles of this decade, in turn, make up the ground and vanishing point of Matthew Weiner's historical re-imagination. In retrospect, the former *zeitgeist* can be made accessible only with the help of those visual series that emerged from this historical period even as these advertisements also had their effect on this past. Sometimes, these images draw our attention to the violence lurking ever so closely beneath the surface of advertisement's beautiful illusions. At other times, they point to the fact that the feeling of satisfaction and safety that the visual narratives of advertisement encapsulate for us are a necessary and viable protection against the knowledge of real injustice and deprivation not *despite* the fact that they disclose the illusion on which the American promise is

predicated, but rather *because* they do so. They are an instance of what Lauren Berlant calls 'cruel optimism.'[53]

However, both image sequences—the news broadcasts and the advertisement campaigns—share a common claim: Only on the level of the cultural imaginary can a meaningful coherence be found for the haunting of the nation by its traumatic history of violence. A reference to the real of the past adheres to the news broadcasts that are interpolated into the fictional world of Matthew Weiner's characters. At the same time, they draw their power from the fact that we recognize these familiar news images of past historical events. Like the visual stories Don and his team create, they belong to the image repertoire of the 20th century. *Mad Men*, thus, not only speaks about the history of war that weighs on the cultural memory of America, but also recalls how we continue to be haunted by the images of this national violence as well.

The Moon Belongs to Everyone

Nothing is secure but life, transition, the energizing spirit. People wish
to be settled; only as far as they are unsettled is there any hope for them.

Ralph Waldo Emerson

On May 25, 1961, in his historic speech before a joint session of congress, John F. Kennedy defended his request for additional funding for his space exploration program by proclaiming: "I believe that this nation should commit itself to achieving the goal, before this decade is out, of landing a man on the Moon and returning him safely to the Earth." Given that he was not putting forward a new military doctrine but instead pitching a doctrine of freedom, more than merely scientific progress was at stake. "In a very real sense," the young President added, "it will not be one man going to the moon—if we make this judgment affirmatively, it will be an entire nation. For all of us must work to put him there."[54] The moon landing, which took place on July 20, 1969, was conceived as the beginning of a new era, not least of all because the wish to carry the American way of life all the way to the stars was utterly congenial to the notion JFK had already proposed in his acceptance speech, namely that the nation was standing on the edge of a New Frontier: "The frontier of unknown opportunities and perils, the frontier of unfilled hopes and unfilled threats." Not only uncharted areas of science and space, however, lay beyond that frontier, as Kennedy reminded the American people, but also the unsolved problems of the ongoing Cold War, the unconquered problems

of racial and religious prejudice, and the unanswered questions of the unequal distribution of wealth.

If the space exploration program came up with a very concrete frontier whose resources might be tapped, the moon landing itself, staged as a magnificent media event, was meant to reassure a still confident nation in its capacity to wonder; to re-confirm its hopeful vision of the future. At the same time, the additional challenge that an American astronaut should not only set foot on the moon but also return home safely, could be deployed as a scintillating protective fiction that allowed the nation to screen out the far less readily solvable internal contradictions and conflicts it had come to be faced with in the course of the same era, not least of all the fact that many G.I.'s were not being returned safely from Vietnam. Ironically, however, this project, which was achieved in the same decade in which it had been conceived, also marks the end of an era. In the act of its realization, the collective dream also exhausted itself.

References are made to the space exploration program early on in *Mad Men*, touching on the fact that, from its inception, this doctrine consisted both in a viable vision for the future and a response to current danger. In order to persuade Don to use space travel as their frame of reference for a new Right Guard campaign, the copy writer, Paul Kinsey, points out to him that even the spray itself has the shape of a rocket. For this reason he has asked Sal Romano to produce drawings in which the man in the advertisement poster resembles an astronaut. A yellow moon in the sky above his head serves as backdrop to a scene whose tag line reads: "This thing is from the future, a place so close to us now, filled with wonder and ease" (MM 1.2). Don, however,

responds to this suggestion by pointing out that for some people it is actually far more disconcerting to think about the future. "They see a rocket, they start building a bomb shelter," he explains, "I don't think it's ridiculous to assume we're looking for other planets because this one will end." For this reason, he resolutely rejects Paul's proposal. A few episodes later, while riding the elevator with Don, Roger complains about a traffic jam on Fifth Avenue. Don points out to him that this is because of the parade for Col. John Glenn, who, on February 1962, was the first American to circle the earth as part of the Friendship 7 mission. Cynically, the war veteran Roger voices his amazement at what passes for heroism these days: "It's not like people were shooting him" (MM 2.2). Don, however, immediately recognizes the advertisement value, calling him a winner: "Square jaw, false modesty. Looks like he just took off his letterman jacket." With his entire demeanor exuding confidence, this former Marine Corps pilot has become the epitome of a public icon, able to draw attention away from all threats to national security posed by the Cold War. Furthermore, the fact that this conversation between Don and Roger takes place in an elevator extends the heterotopic value that is ascribed to this mobile site in *Mad Men* by gesturing towards the far larger trajectory of movement the space ship can undertake.

Sometimes the murky interface between optimistic expectations associated with space travel and real military danger, of which the space exploration program is also part and parcel, is directly addressed. So as to prepare Pete for their visit to a rocket fair in Los Angeles, Don explains to him: "Every scientist, engineer, and general is trying to figure out a way to put a man

on the moon or blow up Moscow, whichever one costs more" (MM 2.10). Their goal is to persuade the congressmen who will be attending this convention to hire Sterling Cooper to advertise aerospace for them in their districts. After the agency actually succeeds in garnering a contract with North American Aviation, which involves designing a campaign for Senator Murphy from California, who is close to the Defense Department, the fraught issue of the military tie-in once more comes up. While Don's team would prefer avoiding any direct reference to bombs, the aircraft manufacturers wish for a more complete picture of what they are offering with the Guidance and Control System for the Minuteman II: "Defense, cutting-edge technology, and, of course, the Moon" (MM 4.10). The national confidence that, in the course of the 1960s, the space exploration program stands in for is also meant to sell the idea of national defense, even if, in their search for new frontiers, the manufacturers of the Minuteman II are precisely not concerned with the end of the world but rather the political take-over of other countries.

Bert Cooper, in turn, watches the development of Project Apollo with unequivocal elation. To him, it represents the pioneer spirit of persistent advancement that also makes up the optimistic kernel of the American dream. In a moment of emergency, he can confidently look to this project while figuring out how to resolve the issue at hand. Initially, nothing fitting comes to his mind, for example, while he is trying to compose the obituary for Ida Blankenship (Randee Heller), his former lover, who unexpectedly died at her desk in front of Don's office. In response to Roger's question what they should put as her profession, he cannot accept the designation 'per-

sonal secretary' and declares instead: "She was born in 1889 in a barn. She died on the 37th floor of a skyscraper. She's an astronaut" (MM 4.9). He derives from the space exploration program a sense of self-confidence. The view that falls back on the earth from outer space mirrors his trust in the possibilities of unlimited and unencumbered upward mobility.

Don will himself trust in the pioneer spirit when it comes to turning a crisis into a lucky opportunity. Because American Airlines has brought the date of their presentation forward by a week, the partners and their teams are all forced to come into the office on Palm Sunday. In this case the biggest challenge is not any association with the military industrial complex but rather the crash of an American Airlines plane a few weeks earlier. Suddenly, Don storms into the open-plan office, where the others are doggedly working, and once more turns advertising a product into the question of promoting a national project per se. "American Airlines is not about the past any more than America is," he declares ecstatically, "Ask not about Cuba. Ask not about the bomb. We're going to the moon." Somewhat taken aback by this outburst, everyone turns towards him, only to be instructed that they will need to start again completely from scratch: "There is no such thing as American history, only a frontier. That crash happened to somebody else" (MM 2.4). The hope and promise encapsulated by the idea of being able to travel to the moon is pitted against all memories of a vexed past, including the sense of responsibility connected with this past. The threat emanating from a future based on space exploration on the one hand and, on the other, overcoming current conflicts owing to which this project was launched in the first place, balance each other out.

Repeatedly the moon also makes an appearance in other pitches as a desirable destination. In the middle of the night, Connie Hilton (Chelcie Ross) calls Don because he has suddenly been seized by a vision: "I want Hiltons all over the world, like missions. I want a Hilton on the moon. That's where we're headed" (MM 3.9). Not least of all because Connie understands the expansion of his hotel chain as his contribution to the Cold War's struggle against communism, he will only accept an advertisement campaign in which the moon plays a key role. Since Don does not comply with this preposterous wish, Connie disapproves of his presentation. As excellent as the work may be, it has missed the ideological message around which his business revolves. The moon as a sign for a goal yet to be achieved does, however, shape a different advertisement campaign. Here it is not about the comforts of home that a familiar hotel chain can offer to Americans in foreign places, but rather the enduring idea of 'home sweet home' itself. Megan comes up with a series of short film sequences for Heinz Baked Beans, in which, over and again, a mother serves these beans to her son, from the Stone Age to the present. The final film sequence is set in a small moon kitchen. The boy has just taken off his space helmet. Through the window one can see the earth in the far distance. The slogan Megan proposes for her series of homely scenes confidently proclaims: "Heinz Beans—some things never change" (MM 5.7). In her advertisement strategy, the future represented by a life on the moon is anything but menacing, because it sentimentally places its trust in the constant return of the same, namely the nourishing love that a mother feels for her children, wherever they may be. Megan's brilliant

spin on space exploration consists in pitting the individual's will to survive against all possible danger, present and future.

The numerous allusions to space travel finally culminate in the episode "Waterloo" (MM 7), in which the success of the Apollo 11 moon landing is consistently also conceived in terms of the possibility that it could have failed. Utterly enthralled, Bert watches the liftoff on TV, while Peggy and Pete, preparing for their big Burger Chef sales pitch the next day, can only hope that everything will go smoothly. While Bert sees Apollo 11 exclusively as the fulfillment of his vision of the future, they are far more pragmatic in recognizing the possible consequences that a botched landing would have for their everyday work. Then, all the characters assemble, albeit in different constellations and in various places, to watch this epochal event. What connects them is the news broadcast—the flickering black-and-white images on different TV screens, Walter Cronkite's voice-over commentary, and finally Neil Armstrong's assessment, spoken while taking his first steps on the surface of the moon: "That's a small step for a man, one giant leap for mankind" (MM 7.7). The reverse shots to these iconic news images are group portraits: Don and his team in a hotel room; Bert and his African American maid in his living room; Roger with his first wife, grandson and son-in-law; Betty with her children, her second husband and his extended family. These vignettes of collective wonder, of national pride, are also indebted to the unfamiliar view of the planet Earth now suddenly made possible from the position of the moon, entailing a radically external perspective on oneself, and, as at the beginning of the Kodak pitch, we as the audience seem to look at them from the TV screen.[55] The

rapt involvement in this seemingly incredible event attests to a collectively shared fantasy, to a sentimental bond that consolidates them into a series of static self-portraits, even if this achieved unity will only be sustained for a short moment. Soon, the individual characters will turn back towards other matters, confront once more their ordinary everyday lives. In retrospect, one will come to recognize that it had not been a momentous event after all.

The moon landing: A shared sense of community.

The next day, during her sales pitch for Burger Chef, Peggy will invoke the notion of an imaginary community, putting all prevailing antagonisms on hold for the duration of the TV transmission of the moon landing. As she explains to the clients, who are waiting curiously for the line of argument she will take, she is not sure what she marveled at most: "The technological achievement that put our species in a new perspective or that all of us were doing the same thing at the same time" (MM 7.7). Precisely these two achievements—gaining a new view of humanity on the one hand and, on the other, image formulas for the sense of social cohesion that can be mobilized only in extraordinary situations—are what the previous sequence of group portraits had put on display. Given that the advertisement strategy Peggy is presenting is predicated on the idea of celebrating something special in the everyday routine, she pits the visit to a Burger Chef restaurant against staying at home and eating in front of the TV set. The latter is conceived in terms of the many differences that, in the course of the 1960s, can come to tear the American family apart. Her reference to the desire for solidarity that they had all experienced the evening before, in turn, brings a contradiction of its own into play. While, for a brief period, the moon landing had come to mask all internal conflicts, the sense of community that the various characters were able to share with each other itself thrives on the knowledge that it was an exception. The extraordinary invariably turns back into the ordinary.

That Bert should die at precisely the moment when his dream of America comes to be realized on his TV screen is touchingly consistent with the role he has played throughout the show. His

desire for the nation was completely satisfied that night. Over the dead body of this old-fashioned patriarch, however, the end of precisely the era that played itself out under the auspices of getting a man to the moon and safely home again comes to be negotiated as well. At the end of *Mad Men*, neither the agency he founded with Roger's father nor the kind of business ethos for which he always stood will continue to exist. It is, however, not the last time that Bert will give voice to the sparkling dreams associated with the moon. After the partners have asked all the employees of SC&P to assemble on the upper floor of their offices so as to commemorate the dead man, Don alone goes back down the stairs to the lower floor, heading toward the office he has been able to once again conquer for himself. The merger with McCann Erickson has re-installed him as the sovereign head of creative. Suddenly, however, the voice of the dead man stops him. "Don, my boy," Bert Cooper's spirit calls out to him. Once Don, interpellated by this call, turns around, Bert begins to sing a song about the moon. A small troop of secretaries accompanies him as the showgirls in his uncanny tap dance. Then, one last time, he sings the refrain: "The moon belongs to everyone, the best things in life are free" (MM 7.7).

Bewildered and at the same time deeply touched, Don watches the song and dance routine that implicitly recalls Robert Morse's performance in the musical film *How to Succeed in Business Without Even Trying*, which came out in 1967. The message Bert Cooper has for us, speaking from beyond the grave, is pure ideology. It offers up a simple imaginary solution for the panoply of unresolvable antagonisms that inform the daily power struggles—in the family, the agency and the nation.

Then Bert's ghost withdraws into his former office and, briefly turning around on the threshold, waves one last time to Don before the door falls shut. This confidence trick, with which the seventh season marks its halftime, has a fissure through which the real appears. If we, along with Don, have become ghost-seers, we also know that, with the egalitarian message the dead man has invoked, he is offering us a benign delusion. The idea that the best things in life are free, which goes in tandem with the unfettered possibility of projecting one's fantasies onto the moon, is as much a protective fiction as the belief that the moon landing had brought about national unity—necessary even if untenable. The music has once more fallen silent, much as the news images of this magnificent event have disappeared from the TV screens. Business goes on as usual. It was to have been only a very brief moment of exception, even if one of utter enthrallment. The one man who enjoyed it unequivocally is now gone. In his account of Apollo 11, Norman Mailer finds a pointed explanation for the ephemerality of this event that is applicable to its historical re-imagination in *Mad Men* as well. For one day, the world applauded America, "but something was lacking, some joy, some outrageous sense of adventure." It was almost, he adds, "as if a sense of woe sat in the center of the heart. For the shot to the moon was a mirror to our condition—most terrifying mirror; one looked into it and saw imitations of a final disease."[56]

Going to Commercial

> *I have always been able to live with ambiguities.*
>
> Matthew Weiner

If *Mad Men* begins with a pitch, it ends in a vision. An early morning meditation session is taking place at the Esalen Institute. "Mother sun we greet you," the spiritual leader calls out to the sun that has begun to rise over the western shore of the American continent. While the camera pans along the other participants sitting cross-legged on the grass, he continues: "The new day brings new hope. Lives we've led, the lives we get to lead." The moment the camera captures Don Draper's figure, we hear the voice-over proclaim: "New day, new ideas, a new you" (MM 7.14). The metallic ding sound of a bell serves as the signal that all are meant to join the spiritual leader in the om mantra chant. The camera, in turn, moves into a close-up of Don, and, after we hear a second ding sound, a broad smile begins to spread across his face. The sound is clearly psycho-diegetic, signaling that we have moved into the vision that has once more spontaneously overcome him, in this case with his eyes closed. At first he hears only the voice of a single young woman singing in his inner ear, then the montage segues to the iconic "Hilltop" commercial for Coca-Cola that McCann Erickson launched in 1971, albeit under somewhat different circumstances. Significantly, it is the one successful advertisement campaign for which we are not given the pitch. And it is the first actual commercial that is not interpolated into the

fictional narrative of *Mad Men* intradiegetically, flickering across some TV screen. Instead, like a real commercial break, it is spliced together with the previous scene, suggesting a narrative succession of events. By virtue of this montage, Matthew Weiner's retrospective re-imagination of this decade and the actual 1971 "Hilltop" Coca-Cola commercial, encapsulating like a pathos formula the cultural intensities of the era, are joined together. Today, the "Hilltop" commercial may seem like the epitome of early seventies kitsch, but, as Matthew Weiner has insisted, his decision to end *Mad Man* with this Coca-Cola ad is not be taken as a cynical comment: "To me it's the best ad ever made [...] That ad in particular is so much of its time, so beautiful."[57]

At the same time, on the diegetic level, Don's final vision offers a lighthearted counterpoint to the dark hallucinations that drove him to the farthest edge of the West Coast, given that this commercial, also, works through psychic residues remaining from the emotionally unsettling weeks he has just spent driving across the American continent. During the meeting in which he and his partners found out that their agency SC&P would cease to exist, Jim Hobart had whispered the word 'Coca-Cola' to him as bait. Later, after he had taken flight from Manhattan, the owner of a motel had asked him to repair his old Coca-Cola vending machine (whose sound is also similar to the ding sound initiating the om-mantra). As an incentive for him to return to McCann, Peggy, in turn, had asked him during their last person-to-person call whether he was not excited about working on the Coca-Cola account. Moreover, in the front row of the chorus of the "Hilltop" commercial, a young woman appears

who, like the receptionist working at the Esalen Institute, has braided red ribbons into her hair.

But it is equally useful to recall that already in the first season, while trying to lure Don into working for him at McCann Erickson, Jim Hobart had arranged a photo shoot for Coca-Cola with Betty. While he ultimately did not make use of this material because Don decided to stay with Sterling Cooper, two sets of photographs were visually interpolated into the film narrative, signifying a potential though not realized advertisement campaign. At the same time, the location where Don has his final inspiration is also not incidental. In the second season, California was the place where he was able to retrieve his psychic balance to such a degree that he was able to return home to his family (even if this reunion would barely last another year). In a similar vein, the cut that directly splices together Don's self-confident grin and the actual realization of what we are to take as his inner vision also constitutes a passage from mourning into a new day. After the psychic meltdown, which culminated in the tearful embrace of the stranger, Leonard, Don can now once more address himself to the ordinary. During this early-morning meditation, he has turned his back on the Pacific Ocean and his closed eyes are directed instead toward the sun, rising in the East. If, furthermore, the second ding sound recalls the many elevator doors that, throughout *Mad Men*, we heard opening onto the offices on Madison Avenue, it is also a proleptic sign that Don Draper will, once again, have arrived. This return to the world of advertising is poignantly cast as a narrative ellipsis, as the dash connecting his early morning vision and its actual execution. By going directly to the finished

Betty Draper's Coca-Cola advertisement.

"Hilltop" commercial, the editing of this final sequence offers up only the effect his inspiration will have had.

It is, thus, important to recall the scenes leading up to this vision: After the perturbing therapy session, Don had initially sauntered to the cliff behind the Esalen Institute in order to gaze forlornly at the ocean. The camera had captured him from the side, enveloped in the misty light of the setting sun, and, although we faintly perceive that he is still wearing the jeans and checkered flannel shirt so uncharacteristic for him, his upright figure also evokes the black silhouette of the opening credit sequence. During the early morning meditation, in turn, he is again wearing a fresh white shirt, and, sitting cross-legged on the grass, his body is sharply illuminated by the morning sun.[58] Embodying the dramaturgic principle of seriality, Don has arrived again at the point from which he started out. The renewal, which, by way of transitioning between these two scenes, the spiritual leader pronounces—with the beginning of his voice-

over already superimposed onto the dusk scene and thus setting in a few seconds earlier than the dawn meditation scene it actually belongs to—has recourse one more time to the logic of second chances so pertinent to the direction Don's story takes in *Mad Men*. This new day is one that asserts hope, that anticipates new prospects, that promises regeneration without, however, already determining how these expectations are to be realized. The new day that is about to arrive is not radically different, it does not entail a complete break with what has come previously. Instead, it consists in a continuation of the very repetition loop we have already been privy to.

Now Don will be able to begin again, albeit with a minimal difference. The anagnorisis he had the previous day does not, therefore, entail a complete reversal of his existence, it is not to be thought of as the conclusion and fulfillment of the sequence of second chances that made up his life so far. He has reached the frontier of the far West and, therefore, needs to turn back East to start anew. Perhaps he has come to recognize that retirement is not an option for him, because his creativity will not let go of him, just like the memories that persistently haunt him. For this archetypical American hero there can, in any case, be no fundamental transformation, only an adjustment to the change in times. For him—and therein lies a seminal difference between 21st-century quality TV and the classic modern novel—there can be no tragic catharsis. His confessions do not culminate in moral redemption, they have no legal consequences, nor do they have any substantial impact on anyone including himself. They do not even entail narrative closure. Instead, what we are called upon to imagine is his

Happy Endings: Pete's remarriage with Trudy.

return to his ordinary everyday work, based on the effect it will have had—the commercial for Coca-Cola.

If, however, the reshaping of mourning into ecstasy is dramaturgically presented as a passage, leading from Don's walk toward the ocean at dusk into a meditation at dawn, we are presented with several narrative endings. For the other characters a new day is about to begin as well. Far more clearly than Don, many of them have come to understand something about themselves, have drawn conclusions from this self-knowledge and have made decisions accordingly. Thus, interpolated in between Don's tearful embrace of a stranger and his walk to the cliff, we are given a series of vignettes, showing us how the lives of these other characters will continue. Pete, together with his radiant wife, Trudy (Alison Brie), and their young daughter, is about to board a private jet. Reunited with his family, he will begin a new life as chief executive of Learjet in Wichita, Kansas. Equally cheerful, Joan hands over her son to her mother,

Happy Endings: Joan's success as business woman.

who will take him for a walk in the park, so that Joan, having founded her own production company called Holloway-Harris, can work undisturbedly. She has turned her living room into a home office. The pinboard on the wall separating it from the kitchen, covered with a plethora of scribbled notes, allows us to surmise that November, 1970, is already well booked. Roger is spending his honeymoon with Marie, the mother of Don's second ex-wife Megan, in Paris. They are sitting in a bistro and he orders champagne and lobsters. The intimate camaraderie shared by this mature couple suggests that this marriage may actually work. Don's daughter, Sally, has assumed the position of her mother, who in turn has come to terms with the fact that she is dying of cancer, but is now too weak to take care of domestic chores. While washing the dinner dishes, Sally is wearing her mother's yellow rubber gloves. Betty, seated behind her, a cigarette elegantly poised in her hand, is quietly reading a newspaper. And Peggy is once again working in her office deep

Happy Endings: Roger's honeymoon in Paris.

into the night. At first she is typing up something at high pitch, her gaze concentrated on the words that are emerging on the paper in front of her. Then Stan joins her and, as she looks up at him, he kisses her softly on the forehead, before they both look at what she has just written. It is this gaze that leads to the lap dissolve, revealing the silhouette of their former creative director standing in the sunset behind the Esalen Institute.

The pathos of the violin music accompanying this series of vignettes on the soundtrack unequivocally indicates that they are to be taken as an ironic yet also affectionate concession to our desire for a happy ending. We want to be assured that these characters, who over seven seasons have become familiar friends, have indeed achieved a satisfying everyday life, before we, too, can finally leave the world of *Mad Men* behind. One last time, the parallel editing connects the individual characters who have already gone their separate ways, splicing them together into an affective community. This coherence signifies

Happy Endings: Sally takes on Betty's position.

both the promise of happiness for them and serves as a pitch aimed at us regarding the pleasurable resolution of social antagonisms, which, on the level of the cultural imaginary, quality TV can still offer us today. And yet, it is important to note that the final episode of *Mad Men* does not end with this sequence of redemptive vignettes. Instead, given the lap dissolve that brings the two coasts of America together in one superimposed image, we return once more to Don. This lap dissolve, however, also fuses Peggy's nocturnal work with Don, standing at the cliff behind the Esaline Institute at dusk, gazing over the ocean, out of which his early morning vision arises. It remains open whether we are to take it that his inspiration is the result of her suggestion, or whether we are to imagine her mentally coaxing him back to Manhattan's Midtown. Or is the Coca-Cola commercial an idea that they worked out together?

What we do know with certainty though is that we are dealing with a vision that no longer takes place on the same

diegetic level of the narrative where Don came to experience self-knowledge. Not only do the vignettes, functioning like an extended subordinate clause, separate this moment of anagnorisis from the meditation the next morning. As the only lap dissolve in the entire interpolated series of closing images, Stan and Peggy's gaze at the copy she has written, superimposed on Don's ecstatic awakening, also draws our attention to a narrative break. At work in Don's final vision is a metafictional ploy. During her person-to-person call with Don, Peggy had urged him twice to come home, even if, the first time round, he had desperately asked "where?" (MM 7.14). *Mad Men* can find no closing shot for the return of a hero, to whom all the homes he has lived in—whether the brothel in Hershey P.A., the villa in Ossining N.Y., or the penthouse on the upper East Side—have remained uncanny habitations. Instead, the scene, performing the reawakening of his creative genius, serves as our point of exit from a fictional world that, over seven seasons, we were allowed to participate in. With closed eyes he looks forward into a future, which, in the shape of an actual commercial from the year 1971, at once draws us back into the force field of the past. The double time that, owing to Don Draper's memory work, kept resurfacing in *Mad Men*, is sustained through to the end. With the iconic "Hilltop" commercial, real history enters into the past of a fictional world that Matthew Weiner historically reimagined from the position of his own present, even as it leads us back into our contemporary moment. After all, the cut, leading directly to the Coca-Cola commercial, also self-consciously picks up on the reality of television programming, in which a set of commercials is used to transition from one show to the next.

A lap dissolve fuses the East and the West Coast, night and dusk.

At the end of *Mad Men*, furthermore, we once more have a slogan that, like Lucky Strike's "Its toasted," has become fully ingrained in a global cultural imaginary: "Coca-Cola. It's the real thing." Young men and women from all over the world stand on a hilltop and, with their song, proclaim a collective desire for a global sentimental bond, achievable at a future moment in time. The fact that everyone is holding the same Coca-Cola bottle in their hand further serves as the corporeal testimony of this wish for shared communality: "I'd like to buy the world a home and furnish it with love." As Matthew Weiner has resolutely pointed out, "five years before that, black people and white people couldn't even be in an ad together, okay?"[59] At the same time, deployed as metafictional closure, this commercial offers its own comment on the very promise of happiness, on which the string of short sequences that serve as the transition between Don's self-recognition and his vision are predicated. The idea of a home, promising security, happiness and human

solidarity, is being invoked as a possibility still to be achieved; as an ideal that one can yearn for, indeed must strive for, even if actual sites of habitation are more often than not shaped by quiet despair, as the closing montage sequences of many episodes in *Mad Men* attest to. For Betty, both of the homes she tried to sustain for her family proved to be a lethal prison, while, for Peggy, home was the place from which she, like her male colleagues, consistently fled, preferring instead the battlefields of the business world. But precisely because in *Mad Men* the homes in which the characters actually live emerge as sites of conflict, quarreling, betrayal, misunderstandings, secrets and deep solitude, the show also wants to retain the fantasy of a home furnished with love, albeit as a commercially produced and disseminated fiction. After all, it was precisely this notion of an imaginary community that many of the sales pitches sought to promote along with the particular consumer good; so to speak as their imaginary surplus. The Lucky Strike cigarette, the Hershey's chocolate bar, the Coca-Cola bottle—they all embody the dream of an achievable but not yet achieved satisfaction, which, as a viable and resilient fantasy, also makes up the invisible cord linking these cultural insignia. And they stand for America as home in an imaginary sense.

Equally decisive, however, is the following: With this metafictional closing sequence we return, once more, to the visual world of advertisement as the logical conclusion to the time travel that Matthew Weiner has shared with us. Going to the "Hilltop" commercial means, on the one hand, ending with the claim that this particular soft drink is "the real thing." On the other hand, it also entails ending with a commercial to which,

Don's passage from quiet mourning into the ecstasy of a new morning.

within the visual history of America, the reference of the real itself adheres. In *Mad Men*, we repeatedly found news broadcasts from the sixties interpolated into the diegesis of the fictional narrative so as to draw attention to and affectively incorporate a politically charged event—such as the campaign between John F. Kennedy and Richard Nixon, the assassinations of John F. Kennedy and Dr. Martin Luther King, the suicide of Marilyn Monroe, and the moon landing. The Coca-Cola commercial, in turn, also performs an intrusion of the real into the fictional world, only in this case, it actually comes to replace the fiction as well. This commercial really did happen, really was aired worldwide. Going to commercial at the end of a TV show that was consistently concerned with a historical re-imagination of the 1960s (and a fictional account of the production of ads and TV commercials), has its own affective effect. The real does not break into and disrupt the fiction as a news broadcast but rather as an aesthetic advertisement image formula, containing

the pathos of this watershed moment and allowing it to flare up again. Precisely as a mediated representation, the past adheres to the colors of the old film stock, to the timbre of the voices, to the body gestures of the singers.

In contrast to *Mad Men*, the Coca-Cola commercial is, in fact, a time capsule in the strict sense of the word. Perfectly encapsulating the *zeitgeist* of 1971, this advertisement grabs us emotionally—once again—and allows us to intellectually grasp this historical moment as well. Consistently to the end, the dictum of Pop Art hovers on the edges of *Mad Men*'s perfectly styled historical refiguration of the past: Our perception of reality is shaped by representations of it. For precisely that reason, the "Hilltop" Coca-Cola commercial is a real representation of this time; genuine, pure and authentic. Conceived with the cruel, violent war in South-East Asia as its implicit backdrop, the choreographed community of young men and women of different races and religions, each holding a Coca-Cola bottle as though it were their torch, while making an appeal for peace and harmony speaks perfectly to the end of an era of cultural promise, upheaval and disappointment—as a fantasy of what could have been, and what could still be achieved, nevertheless.

As in the previous pitches, Don's genius reveals itself in the fact that, having recognized the desires of his fellow men and women, he has come up with a visual story resonating with his own personal image repertoire. In this case, however, we are dealing with a real commercial that is subsequently being ascribed to the genius of a fictional character. If, with this vision, the real of the past returns to us as well, the metafictional point consists in the fact that Don finally dissolves completely into

the intuition that his inner voice has whispered to him. As a fictional character who has dreamed up a commercial that really existed, he also vanishes into the surface of the image. By virtue of a series of lap dissolves, with the camera repeatedly panning back and forth along the beaming faces of the singers, the separate individuals that make up the chorus, in turn, come to be blended together into a multi-layered composite image. At the end of the "Hilltop" commercial, once the camera has moved into a long shot, the close-up of an enraptured young woman, superimposed over the crowd, is shown to unite all the separate figures into one collective body. If this mythic sign of global solidarity is pitch perfect for this specific historical moment, it also transcends it. The image world of the past has caught up with us, and at the same time we have finally left behind the realm of fiction, which had allowed us to participate empathetically in a past world, no longer with us. A visual story, produced explicitly for our pleasurable consumption, proves to be the real thing, precisely when it reproduces the affective intensities of a particular historical moment even as, by virtue of this subsequent performance, it also allows these energies to live on, to be sustained. That was always the wager of *Mad Men*. Matthew Weiner's creation dissolves into this serial temporal loop, even while it keeps evolving—in our own imaginary.

Giving Coca-Cola a new face: The individual dissolves into the body politic.

Notes

1 The acronym 'MAD' is, of course, also a reference to the concept of "mutually assured destruction" permeating America's Cold War culture at the time.

2 Andy Warhol is famous for declaring: "If you want to know all about Andy Warhol, just look at the surfaces of my paintings and films and me, and there I am. There is nothing behind it. I see everything that way, the surface of things, a kind of mental Braille, I just pass my hands over the surface of things," quoted in Gretchen Berg, "Andy: My True Story," *Los Angeles Free Press* (March 17, 1963). For a discussion of the way the Warhol Economy, by fusing surface and depth, also argued for a conflation between art and commerce, for a dissolving of the boundary between high and low culture, as well as the way Warhol's concept of art can be seen in retrospect as both a comment on and a catalyst for 1960s advertisement and consumer culture, see Ryan Gillespie's article "Art, Advertising, and Nostalgia for the New in *Mad Men*," in Danielle M. Stern, Jimmie Manning and Jennifer C. Dunn (eds.), *Lucky Strikes and a Three Martini Lunch: Thinking about Television's Mad Men* (Newcastle upon Tyne: Cambridge Scholars Publishing, 2012), pp. 44–59.

3 In his essay, "The Selling of Mad Men: A Production History," in *Mad Men. Dream Come True TV* (London: Taurus, 2011), p. 17, Gary R. Edgerton includes the original live action shot of Don Draper that, transformed into the iconic silhouette, came to serve as the show's signature image over seven seasons. This action shot, in turn, was primarily used by AMC as a publicity image for the first season in order to sell the enigma of *Mad Men*'s protagonist. In this photograph, we

see Don Draper mirrored in the glass window of his office, gazing out at the nocturnal cityscape of Manhattan's illuminated skyscrapers. Rather than looking out at a completely open horizon, his gaze is both limited and doubled. He cannot look beyond his world—the midtown office buildings—even as he faces his own reflection. Only at the end of the seventh season will he find himself, as will be discussed in detail in my conclusion, in a similar sitting position, with small but seminal differences. During the early morning meditation he is, of course, not sitting in an armchair but on the grass and we see him from the front rather than from the back. He is also no longer casually holding a cigarette in his hand but has instead assumed the om mantra meditation pose. And, rather than looking outward at an open horizon, he is looking inward.

4 In *Film Nation: Hollywood Looks at U.S. History*, revised edition (Minneapolis: University of Minnesota Press, 2010), Robert Burgoyne, drawing on Mikhail Bakhtin's notion of genre memory, argues compellingly that any cinematic rewriting of history, engaged in an effort to create an imaginary community for the contemporary nation, both calls up the past and responds to the present. Double voicing thus entails shaping and carrying cultural experience from one generation to another by virtue of an aesthetic refiguration of the past. For a discussion of how cultural memory is produced through objects, images and representations see also Marita Sturken, *Tangled Memories. The Vietnam War, the AIDS Epidemic, and the Politics of Remembering* (Berkeley: University of California Press, 1997).

5 Quoted in Fred Kaplan, "Drama Confronts a Dramatic Decade," *The New York Times*, August 9, 2009; www.nytimes.com/2009/08/09/arts/television/09kapl.html. As Lauren M. E. Goodlad, Lilya Kaganovsky and Robert A. Rushing argue in their introduction to the collection

of essays, *Mad Men, Mad World. Sex, Politics, Style & the 1960s* (Durham: Duke University Press, 2013), Matthew Weiner's show offers a groundbreaking approach to period drama in that it focusses less on an accurate depiction of the 1960s than on using the genre of historical fiction so as to both capture and produce an experience of the present that is intensified by virtue of this revisitation of the past. In a similar vein, Linda Beail and Lilly J. Goren claim in the introduction to their edited volume *Mad Men and Politics: Nostalgia and the Remaking of Modern America* (London: Bloomsbury, 2015) that over and beyond its impact on popular culture, this show explores contemporary facets of American identity through the lens of the 1960s by telling stories that illuminate political dilemmas regarding freedom, identity, and social inclusion that continue to haunt the nation.

6 Frank Rich, "'Mad Men' Crashes Woodstock's Birthday," *The New York Times*, August 15, 2009; www.nytimes.com/2009/08/16/opinion/16rich.html.

7 Michael Wood, *America in the Movies* (New York: Columbia University Press, 1975), p. xix. As Linda Beail and Lilly J. Goren argue in their article "*Mad Men* and Politics: Nostalgia and the Remaking of America," while the 1950s "created a more prosperous, anti-Communist and imperial America, this refounding was challenged by the social and political events of the 1960s," making the period of which *Mad Men* offers its historical re-imagination one of ambivalent optimism, in *Mad Men and Politics*, p. 6.

8 See Matthew Weiner in conversation with A.M. Holmes on May 20, 2015 at the New York Public Library; www.nypl.org/events/programs/2015/05/20/matthew-weiner.

9 Stanley Cavell, "The Avoidance of Love. A Reading of *King Lear,*" in *Disowning Knowledge in Seven Plays of Shakespeare*, updated version (Cambridge: Cambridge University Press, 2003), p. 115.

10 See Jim Cullen's chapter on the Puritan enterprise in *The American Dream: A Short History of an Idea That Shaped a Nation* (Oxford: Oxford University Press, 2003), pp. 11–34.

11 For a discussion of how Hollywood films have negotiated this ambivalent promise, see Stanley Cavell, *Pursuits of Happiness: The Hollywood Comedy of Remarriage* (Cambridge, MA: Harvard University Press, 1981).

12 Perhaps we get only a silhouette of Don Draper and not a clearly recognizable representation of Jon Hamm in these credit sequences because, while it prefigures the plot, the fact that this falling confidence man is animated and not enacted by an actor suggests it could be anyone.

13 Here, and in the following chapters, the abbreviation stands for: *Mad Men*, Season 1, Episode 1.

14 Part of *Mad Men*'s game with intertextual references is that, in fact, this slogan was actually introduced in 1917, so that by the 1960s it would already have been fully familiar to the American public.

15 In his State of the Union address on January 6, 1941, Franklin D. Roosevelt had declared freedom from fear to be one of the four freedoms he was promoting in a speech aimed explicitly at global disarmament. It was adopted as part of the Universal Declaration of Human Rights, by the United Nations General assembly, on December 10, 1948.

16 See Roland Barthes, *Mythologies*, Trans. Annette Lavers (New York: Hill and Wang, 1972).

17 As such, these pitches are self-reflexive moments of fantasy work used for wish-fulfillment. As Freud notes in his essay "Creative Writers and Day-Dreaming" (1908), the relation of fantasy to time involves three moments, given that while it is linked to some current impression, it harks back to a memory of an earlier experience when this wish was allegedly satisfied, even while it "creates a situation relating to the future which represents a fulfillment of the wish," in *The Standard Edition* vol. IX (London: Hogarth Press, 1959), p. 147.

18 Ralph Waldo Emerson, "Self-Reliance," in *Essays and Lectures* (New York: Library of America, 1983), p. 259. It is interesting to note that not Draper, but his counterpart, Ted Chaough, is twice presented as a reader of Emerson. In his discussion with Peggy, trying to convince her to join him at his own advertisement agency GCC, he quotes the famous passage from the essay "Nature," in which Emerson compares the poet to a transparent eyeball, being nothing but seeing everything. Later, when Peggy fantasizes about being seduced by him, he is holding a book by Emerson in his hand, entitled *Something*.

19 In his afterword to the collection of essays *Mad Men, Mad World, op.cit.*, "A Change is Gonna Come, Same as It Ever Was," Michael Bérubé notes that "*Mad Men* screams that we have not found a solution to the happiness problem" (p. 347). He calls for more discussion of Don's major advertising pitches because, like myself, he reads these scenes as part of the show's critical discussion of the ideological work that advertisement does. The structural irony at work in these pitches, he argues, is such that, even as *Mad Men* calls advertising into question, it perpetually draws us into its lure.

20 Significantly, the first title Daniel J. Boorstin gave to his scathing critique of mass culture manipulation, when it first appeared in 1961,

was *What Happened to the American Dream*. His salient point is that, after WWII, the extravagant expectations of the American project together with the technology of television and other new media produced a culture in which the making of illusions became the business of America, replacing reality by a lot of pseudo-events, see *The Image: A Guide to Pseudo-Events in America* (New York: Random House, 1992).

21 Drawing a slightly different comparison between Weiner's advertisement man and this youthful president, Bob Batchelor and Norma Jones, in their article "*Mad Men*: Framing Advertising History," suggest: "Like JFK, who balanced an admired persona with unsavory private behavior, Don is masterful when tested. He represents the fulfillment of the American Dream, even though viewers understand that everything Draper projects on the screen is a lie," in Danielle Sarver Cooms and Bob Batchelor (eds.), *We Are What We Sell. How Advertising Shapes American Life ... and Always Has. Vol 3: Advertising in the Contemporary Age* (Santa Barbara: Praeger, 2014), p. 11.

22 See also Sean O'Sullivan's discussion of the correspondence between the Kodak Carousel and serial television in his discussion of the Kodak pitch in "Space Ships and Time Machines: *Mad Men* and the Serial Condition," in Edgerton (ed.), *Mad Men. Dream Come True TV*, pp. 115–130.

23 As Svetlana Boym points out, nostalgia is not only an articulation of loss and displacement, but also a celebration of one's own fantasy, which can be both the sign of personal distress as well as the symptom of an age, and thus a collective, historical emotion; see *The Future of Nostalgia* (New York: Basic Books, 2001), pp. xiii–xix. As Lauren M. E. Goodlad notes in her discussion of the Kodak pitch, Don isolates a series of attractive moments, disarticulates them from

concrete history and elevates the sentimentality to an abstract ideal; see "The Mad Men in the Attic. Seriality and Identity in the Modern Babylon" in Goodlad et al. (eds.), *Mad Men, Mad World*, p. 242. The structural irony is such that depleting an image of its historical specificity is precisely what is at issue in the mythic signifier Barthes discusses in relation to advertisement as well. The Kodak pitch thus emerges as a particularly poignant example of the show's self-reflexivity, commenting on this disarticulation even as, by virtue of Don's convincing performance, it charms us.

24 Sigmund Freud, "On Transcience," (1916), in *The Standard Edition*, volume XIV (London: Hogarth Press, 1957), p. 305.

25 Freud, "Creative Writers and Day-Dreaming", pp. 146 and 148.

26 The fact that the final episode of this first season has a double ending indicates that the personal fulfillment Don continues to strive for is as yet uncertain. His dream on the commuter train invokes a return to the happy home he discovered while watching his intimate family snapshots. The reality he actually comes home to is an empty house.

27 Roland Barthes, *Camera Lucida: Reflections on Photography*, Trans. Richard Howard (New York: Hill and Wang 1981), p. 82. See also Irene V. Small, who, in her article "Against Depth. Looking at Surface through the Kodak Carousel," refers to Barthes' discussion of the punctum, in Goodlad et al. (eds.), *Mad Men, Mad World*, p. 182.

28 Barthes, *Camera Lucida*, p. 84.

29 By calling this photograph the navel of Don's pitch, I am, of course, referring to Freud's proposition that each dream has a navel that is unplumbable, and as such marks the point of contact with the unknown. It would take me too far afield to embellish on the interrelation between the navel as a somatic sign for the unknowability of a life marked by mortality, and a drive toward images as an imaginary

recompensation for this traumatic knowledge. I refer, instead, to my own discussion of Barthes' *Camera Lucida* as a rewriting of Freud's *Interpretation of Dreams* in *The Knotted Subject. Hysteria and its Discontents* (Princeton: Princeton University Press, 1998), pp. 87–98.

30 As Hal Foster suggests in his article "Death in America," opening up a line of association between Andy Warhol's engagement with death as what lurks directly beneath the surfaces of his serial images and *Mad Men*'s own duplicitous refiguration of serial product-images, "repetition serves to *screen* the real understood as traumatic. But this very need *points* to the real, and it is at this point that the real *ruptures* the screen of repetition. It is a rupture not in the world but in the subject; or rather it is a rupture between perception and consciousness of a subject *touched* by an image," *October*, vol. 75 (Winter, 1996), p. 42.

31 This is, in a sense, also the culmination of a series of self-pitches we have seen Don present, beginning with his threat, at the end of the second season, to leave the firm if, in the course of their merger with the British firm Putnam, Powell and Lowe, 'Duck' Philips were to become his boss, given that this would curtail his sovereignty as creative director. Then, again, he pitches a merger to Ted in the middle of the sixth season, once he realizes that only a larger agency can get the Chevy account. After the debacle of his misguided confession to the men from Hershey's, he is again compelled to pitch his passion for the creative work he does to the other partners, so as to get them to agree on the merger with McCann Erickson, a decision on which his own return to the agency is predicated. In all cases, these are moments of recuperation, meant to either ward off an imminent danger or allowing him and his agency to emerge from a crisis.

32 Significantly, we never see Don pitch his strategy for the iconic hill-top Coca-Cola commercial at the end of the final season, making this the most poignant of all narrative ellipses regarding sales pitches.

33 F. Scott Fitzgerald, *The Great Gatsby* (1926) (London: Penguin Classics, 2010), p. 192. For a discussion of Don Draper as a quintessential 'frontier hero,' as the American Adam, who moves forward while incessantly reinventing himself, see also Melanie Hernandez and David Thomas Holmberg's essay "'We'll start over like Adam and Eve': The Subversion of Classic American Mythology," in Scott F. Stoddart's collection *Analyzing Mad Men: Critical Essays on the Television Series* (Jefferson, NC: McFarland & Company, 2011). For a discussion of Don Draper as the archetypical grifter and confidence man, see also Lilly J. Goren "If You Don't Like What They Are Saying, Change the Conversation: The Grifter, Don Draper, and the Iconic American Hero," in Beail and Goren (eds.), *Mad Men and Politics*, pp. 35–61.

34 See Sigmund Freud's discussion of repetition compulsion in relation to the shell shocked veterans that returned from the trenches of WWI, as this relates to the work of fantasy where the dreamer repeats a scene over and again because not only can a form of satisfaction be found in reliving the injury, but because re-imagining it is also the source for a creative overcoming of the injury, *Beyond the Pleasure Principle* (1919) *The Standard Edition* vol. XVIII (London: Hogarth Press, 1955), pp. 12-23.

35 Freud, "Creative Writers and Day-Dreaming," pp. 147–148.

36 Alexis de Tocqueville: *Democracy in America* (1835) (New York: Library of America, 2004), p. 587.

37 See Ralph Waldo Emerson, "Circles," in *Essays and Lectures*, p. 413.

38 This phonetic ambiguity is, of course, also picked up when the first African American secretary to be hired by the agency is not only called Dawn but is also given charge of Don's desk.

39 It is fruitful to recall that, according to Freud, the compulsion to repeat is one of the psychic articulations of the death drive. In the case of Don Draper's conviction that he will always have a second chance, *Mad Men* offers a critical spin on the optimism at issue in a culture predicated on constant regeneration. Being able to begin again, and thus repeat (albeit in a slightly different manner) what has gotten one to the point of falling, may be the precondition for restitution. Repeating certain actions, engaging the same conflict over and again may be a form of working through possibilities. But the interminability written into a logic of second chances also implies that there is no way out of the loop that connects falling and resurrection (as shown in the credit sequence), no resolution for this tension, and thus only a repetitive but not a restitutive tendency to the pursuit of renewal. Furthermore, the deceptive charm of a trust in second chances is also challenged in this TV show in the form of all those who are not privy to this opportunity and whose death attests to the cruel limit of this optimism. Analogous to the charismatic sales pitches, these corpses also punctuate Don's story. But they do so as monuments to the collateral damage of the American dream. At the beginning of this lethal series we have Dick Whitman's parents, unable to assert themselves successfully against the poverty imposed on them by the Depression. At the center we find the men, who do not want to or cannot buy into a blind trust in the future: Adam Whitman, who chooses death because he will not relinquish his love for the half-brother who repudiates him, and Lane Pryce, who commits suicide because he cannot imagine a future after the shame of his forgery.

40 Tocqueville, *Democracy in America*, attributes "the strange melancholy that the inhabitants of democratic countries often exhibit in the midst of plenty, and the disgust with life that sometimes grips them as they go about their comfortable and tranquil existences" to their inability to achieve the equality they desire (*op. cit.* p. 628). It seems fruitful to apply this to the specifically American pursuit of happiness as well. The idea of perfectibility, also, recedes without ever disappearing, such that, even as it recedes, it entices the heroes of this dream to chase after it. Even as the American dreamer thinks he is about to finally achieve his goal, it invariably eludes their grasp.

41 Ralph Waldo Emerson, "Nature," in *Essays and Lectures*, p. 10.

42 Stanley Cavell, *Contesting Tears. The Hollywood Melodrama of the Unknown Woman* (Chicago: University of Chicago Press, 1996), p. 212.

43 Emerson, "Circles," in *Essays and Lectures*, p. 405.

44 Although, in the credit sequence, the camera glides along the façades of office buildings, it does this merely to visually capture Don's fall.

45 Michel Foucault, "Different Spaces," *Aesthetics, Method, and Epistemology, Essential Works of Foucault 1954–1984*, volume 2, Ed. James Faubion, Trans. Robert Hurley et. al. (London: Penguin, 1998), p. 178.

46 See the entry on the elevator by Simon Frisch and Christiane Voss in *Wörterbuch kinematografischer Objekte*, edited by Marius Böttcher et. al. (Berlin: August Verlag, 2014), p. 38.

47 During season 6, almost all the elevator scenes take place not at the office but rather in Don's apartment building. It is one of the sites where the affair he is having with his neighbor is both reflected and contested.

48 See also Loren Goldman's discussion of how key figures in the show are deeply marked by their military service, especially Roger

Sterling and Don Draper, in "The Power Elite and Semi-Sovereign Selfhood in Post-War America," in Beail and Goren (eds.), *Mad Men and Politics*, p. 81f.

49 It is fruitful to think about Roger's insistence that traces of the past war are inscribed into the very fabric of peacetime in relation to Nunnally Johnson's film *The Man in the Grey Flannel Suit* (1956), in which Betsy Rath also accuses her husband, Tom, that he continues thinking about the war although it is now over. The melodramatic argument of the film narrative revolves around the fact that, for many veterans returning home from both the European and the Pacific theaters of war after 1945, the optimism of those who had remained on the home front does not apply, even when they are not clinically suffering from anything resembling post-traumatic stress disorder. Nunnally's film can be seen as a model for *Mad Men* not least of all because it, too, rather than arguing for a deflection of war, draws attention to the way codes of war continue to structure the workplace in postwar corporate America.

50 A seminal aspect of *Mad Men*'s historical re-imagination comes into play in these dialogues, given that in the films of the 1960s that serve both as the visual and narrative model for the show such explicit deployment of military vocabulary is rarely found. Only belatedly, as the result of a 50 years aftereffect, but also as a comment on current American culture, is the pervasive presence of military terms in non-military environments explicitly written into the screenplay of the show.

51 See Christoph Bartmann, *Leben im Büro: Die schöne neue Welt der Angestellten* (München: Hanser Verlag, 2012), p. 116f.

52 Wood, *America in the Movies*, p. xiii.

53 In her book *Cruel Optimism* (Durham: Duke University Press, 2011), Lauren Berlant uses this term to speak about an attrition of the fantasy that the good life is achievable in current American culture, or as she puts it, to think "about the ordinary as an impasse shaped by crises in which people find themselves developing skills for adjusting to newly proliferating pressures to scramble for modes of living on" (p. 8).

54 John F. Kennedy, "Special Message to Congress on Urgent National Needs," May 25, 1961, Speech typescript, p. 9, www.jkflibrary.org. For a discussion about the moon landing as yet another instance of America rediscovering itself by looking at itself from outer space, see Gloria Meynen's essay "Wir, die Marsmenschen!" in Wladimir Velminski (ed.), *Sendungen* (Bielefeld: Transcript Verlag, 2009), pp. 265–294.

55 Implicitly, we embody the external view from a historical perspective, but thus also take on the position of the news broadcast, we are, so to speak, in the same place as the transhistorical media transmissions of this event. I want to thank Sabin Jeanmaire for pointing this out to me.

56 Norman Mailer, *A Fire on the Moon* (London: Penguin Books, 2014), p. 327.

57 See Matthew Weiner in conversation with A.M. Holmes on May, 20th, 2015 in the New York Public Library, www.nypl.org/events/programs/2015/05/20/matthew-weiner.

58 Given that, in contrast to the credit sequence, Don is now facing us rather than looking away from us and toward the empty space in front of him, we are—as in the Kodak sales pitch—once more in the place where the images he uses to persuade others, will appear.

59 Weiner in conversation with A.M. Holmes, New York Public Library.

Bibliography

Barthes, Roland, *Mythologies* (1957), Trans. Annette Lavers (New York: Hill and Wang, 1972).

— *Camera Lucida: Reflections on Photography*, (1980), Trans. Richard Howard (New York: Hill and Wang, 1981).

Beail, Linda, and Lilly J. Goren, *Mad Men and Politics: Nostalgia and the Remaking of Modern America* (London: Bloomsbury, 2015).

Berlant, Lauren, *Cruel Optimism* (Durham: Duke University Press, 2011).

Boorstin, Daniel J., *The Image: A Guide to Pseudo-Events in America* (New York: Random House, 1992).

Boym, Svetlana, *The Future of Nostalgia* (New York: Basic Books, 2001).

Bronfen, Elisabeth, *Home in Hollywood: The Imaginary Geography of Cinema* (New York: Columbia University Press, 2004).

— *Specters of War: Hollywood's Engagement with Military Conflict* (New Brunswick, NJ: Rutgers University Press, 2012).

Burgoyne, Robert, *Film Nation: Hollywood Looks at U.S. History* (1971), revised edition (Minneapolis: University of Minnesota Press, 2010).

Carveth, Rod, and James B. South (eds.), *Mad Men and Philosophy: Nothing is as it Seems* (Hoboken, NJ: John Wiley and Sons, 2010).

Cavell, Stanley, "The Avoidance of Love: A Reading of *King Lear*", *Disowning Knowledge in Seven Plays of Shakespeare* (1987), updated version (Cambridge: Cambridge University Press, 2003).

— *Pursuits of Happiness: The Hollywood Comedy of Remarriage* (Cambridge, MA: Harvard University Press, 1981).

— *Contesting Tears: The Hollywood Melodrama of the Unknown Woman* (Chicago: University of Chicago Press, 1996).

Cullen, Jim, *The American Dream: A Short History of an Idea That Shaped a Nation* (Oxford: Oxford University Press, 2003).

Delbanco, Andrew, *The Real American Dream: A Medition on Hope* (Cambridge, MA: Harvard University Press, 1999).

Emerson, Ralph Waldo, *Essays and Lectures* (New York: The Library of America, 1983).

Engstrom, Erika, Tracy Lucht, Jane Marcellus, and Kimberly Wilmot Voss (eds.), *Mad Men and Working Women: Feminist Perspectives on Historical Power, Resistance, and Otherness* (New York: Peter Lang, 2014).

Edgerton, Gary R. (ed.), *Mad Men: Dream Come True TV* (London/New York: I.B.Tauris, 2011).

Fitzgerald, F. Scott, *The Great Gatsby* (1926) (London: Penguin Classics, 2010).

Foster, Hal, "Death in America", *October* 75 (Winter, 1996), p. 36–59.

Foucault, Michel, *Aesthetics, Method, and Epistemology: Essential Works of Foucault 1954–1984*, Ed. James Faubion, Trans. Robert Hurley et. al., Vol. 2 (London: Penguin, 1998).

Freud, Sigmund, "Creative Writers and Day-Dreaming" (1908), *The Standard Edition of the Complete Psychological Works of Sigmund Freud*, Ed. and Trans. James Strachey, Vol. 9 (London: Hogarth Press, 1959), p. 143–153.

— "On Transience" (1916), *The Standard Edition of the Complete Psychological Works of Sigmund Freud*, Ed. and Trans. James Strachey, Vol. 14 (London: Hogarth Press, 1957), p. 305–307.

— "Beyond the Pleasure Principle" (1919), *The Standard Edition of the Complete Psychological Works of Sigmund Freud*, Ed. and Trans. James Strachey, Vol. 18 (London: Hogarth Press, 1955), p. 1–64.

Goodlad, Lauren M.E., Lilya Kaganovsky, and Robert A. Rushing (eds.), *Mad Men, Mad World: Sex, Politics, Style & the 1960s* (Durham: Duke University Press, 2013).

Jameson, Fredric, *Postmodernism, or, The Cultural Logic of Late Capitalism* (1991) (Durham: Duke University Press, 1999).

Mailer, Norman, *A Fire on the Moon* (1970) (London: Penguin, 2014).

McLean, Jesse, *Kings of Madison Avenue: The Unofficial Guide to Mad Men* (Toronto: ECW Press, 2009).

Stern, Danielle M., Jimmie Manning, and Jennifer C. Dunn (eds.), *Lucky Strikes and a Three Martini Lunch: Thinking about Television's Mad Men* (Newcastle upon Tyne: Cambridge Scholars Publishing 2012).

Stoddart, Scott F. (ed.), *Analyzing Mad Men: Critical Essays on the Television Series* (Jefferson, NC: McFarland, 2011).

Tocqueville, Alexis de, *Democracy in America* (1835–40), Trans. Arthur Goldhammer (New York: Library of America, 2004).

Sturken, Marita, *Tangled Memories: The Vietnam War, the AIDS Epidemic, and the Politics of Remembering* (Berkeley: University of California Press, 1997).

Wood, Michael, *America in the Movies* (New York: Columbia University Press, 1975).

Five Iconic Scenes

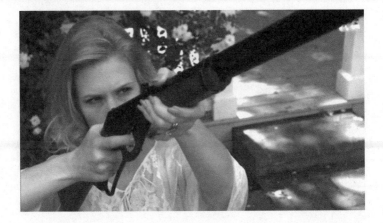

Season 1, Episode 9
"Shoot"

(Teleplay: Chris Provenzano, Matthew Weiner, Director: Paul Feig, Sept. 13, 2007)

A magnificent final tableau: Dressed in her pink morning robe, Betty is standing in the garden behind her house, aiming her hunting rifle at her neighbor's pigeons. Nonchalantly, a cigarette hangs from her perfectly painted red lips. Encapsulated in this image is what, in her bestseller *The Feminine Mystique* (published 1963), Betty Friedan called "the problem which has no name"—the inexplicable unhappiness that came to befall countless American housewives despite the comfort of their homes and the security of their family life. Returning to work as a model for an international Coca-Cola advertisement would have been a way out of this golden cage for Betty. But the offer made to her by the chief executive of McCann Erickson simply used her as bait. What Jim Hobart really wanted was to hire Don Draper. The title "Shoot" conflates the crisscrossed desires at stake. Shooting advertisement photos that thwart Don's wish to reduce his wife to her role as mother transforms into Betty's act of shooting at pigeons that are allowed to fly around freely, so as to screen out her own disappointment. All her hopes are shot to pieces. "Shoot!" is, however, also a euphemism for "shit!" This ladylike curse, too, befits Betty and her rifle.

Season 2, Episode 13
"Meditations in an Emerge"

(Teleplay: Matthew Weiner, Kater Gordon, Director: Matthew Weiner, Oct. 26, 2008)

"Now I am quietly waiting for the catastrophe of my personality to seem beautiful again and interesting and modern"—this is what the case of emergency sounds like in Frank O'Hara's poem "Mayakovsky" from the collection of poems, published 1957, from which this episode takes its title. Three emergencies that must be addressed are intertwined. Betty's surprise pregnancy compels her to forgive Don's infidelities. He is allowed to return home, if only for one more season. A merger with the British firm Putnam, Powel & Lowe, in turn, threatens to drastically compromise Don's power as creative director. This unexpected event is negotiated in the middle of the Cuba Missile Crisis and mirrors the bold political strategy that Kennedy and Khrushchev undertake to prevent a nuclear catastrophe. Don, also, takes an audacious stand, so as to fight for his vision of what advertising should be. Once the emergency is over, everyone pauses for a moment. Return to normal? Not quite. It was only a temporary solution. The international arms race goes on, as does the financial instability of the agency, and Don continues to be seduced by the charms of other women.

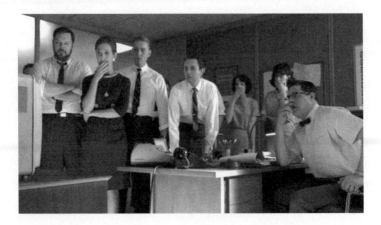

Season 3, Episode 12
"The Grown-Ups"

(Teleplay: Brett Johnson, Matthew Weiner, Director: Barbet Schroeder, Nov. 11, 2009)

At 12.30, on November 22, 1963, the news of John F. Kennedy's assassination brings everything to a halt. At first all the telephones are ringing at the same time in the offices of Sterling Cooper, then no more calls can be put through at all. Petty rivalries and clandestine love affairs are interrupted by the incursion of real violence. Like an invisible cord, the news images on TV connect various sets of characters, provoking different pathos gestures of shock. Without losing his composure, Don assures his family that everything will be okay. But the images that flicker incessantly on the TV screens during the following weekend—shots fired in a basement garage that fatally wounded Lee Harvey Oswald and the burial of the 35th President of the USA—encapsulate a sense of liberating contingency. Not everything must remain the way it was. Betty announces to her penitent husband that she no longer loves him. Trudy Campbell assures her husband Pete that he owes nothing to the partners of the agency given that they do not appreciate him. The news images, interpolated into the dramatic action, render visible the correspondence between public and private crises.

Season 4, Episode 5
"The Chrysanthemum and the Sword"

(Teleplay: Erin Levy, Director: Lesli Linka Glatter, Aug. 22, 2010)

It is a perfect confidence game on the part of Don and his team. Their rivals are supposed to think that they are making a commercial for the competition launched by the Honda Corporation, when in fact it is really only about getting the attention of the Japanese. Joan takes the film director, working for their adversaries, into her false confidence, fully aware that he will immediately pass on the sensitive information. Soon after, Peggy pushes a smart red Honda motorbike along the path of the studio where this director is filming as well, and, while passing him, pretends not to see him. Don's little troupe is clearly putting on a performance and precisely because the dupery is so evident, the others fall for it. "Sorry, closed set," Peggy's helper explains to the curious men who want to watch the filming. What happens behind the closed doors is pure alienation effect—the performance of nothing, drawing its effect precisely from this naught. Only we are allowed to see how Peggy blithely drives around in circles in the empty studio. No spotlights illuminate her, no cameras shoot the action. The scene—graceful and minimalist at one and the same time—could also have been taken from a *nouvelle vague* film. Of course, Don's assessment of the Japanese was pitch perfect. At the end of the episode he has, indeed, won their undivided recognition.

Season 5, Episode 8
"Lady Lazarus"

(Teleplay: Matthew Weiner, Director: Phil Abraham, May 6, 2012)

In Sylvia Plath's eponymous poem, a woman who has returned from her grave pronounces her threat: "Out of the ash I rise with my red hair and I eat men like air." In this episode, two women give in to their destructive desire. The men, whose vanity they target, must comply. Beth, a bored housewife, plays recklessly with Pete's erotic fickleness. His deep blue eyes remind her of the view of the earth from outer space, tiny, unprotected, surrounded by darkness. And yet, she will not abandon her sad marriage for him. Megan, in turn, is only too willing to give up her coveted position as copy writer in her husband's agency, so that she can fully pursue her career in acting. Peggy, indignant at this decision, takes Megan to task, and in so doing, points toward a third option—stubborn, persistent self-assertion. This is less dramatic, of course, but also less wounding for all those involved. The closing sequence of this episode offers a poignant series of nocturnal vignettes, which, as is so often the case in *Mad Men*, revolve around the unsolvable antagonism between the sexes. In silence, Peggy and Stan are working together in the office well into the night. Pete watches Beth pick up her husband at the train station. Megan is completely immersed in her acting class. Just before leaving the apartment, she had suggested to Don, who wants to get a sense of what her generation is all about, that he should listen to the song "Tomorrow Never Knows" on the newest Beatles album *Revolver*. For a few moments, he tries to fathom this sound, then he turns off the music, and walks into his bedroom alone, a glass of whisky in his hand. With the final credits, the music begins again:

"It is not dying."

Mad Men

(created by Matthew Weiner)

AMC, 7 seasons, 92 episodes June 19, 2007 to May, 17, 2015

Players:

Jon Hamm (Don Draper, né Dick Whitman), Elisabeth Moss (Margaret 'Peggy' Olson), Christina Hendricks (Joan P. Harris, née Holloway), Vincent Kartheiser (Peter 'Pete' Campbell), January Jones (Elizabeth 'Betty' Francis, née Hofstadt, first married name Draper), John Slattery (Roger H. Sterling, Jr.), Robert Morse (Bertram 'Bert' Cooper), H. Richard Greene (Jim Hobart), Kiernan Shipka (Sally Draper), Marten Weiner (Glen Bishop), Maxwell Huckabee (Robert 'Bobby' Draper), Jessica Paré (Megan Draper, née Calvet), Aaron Staton (Kenneth 'Ken' Cosgrove), Rich Sommer (Harold 'Harry' Crane), Mark Moses (Herman 'Duck' Phillips), Kevin Rahm (Ted Chaough), Teyonah Parris (Dawn Chambers), Michael Gladis (Paul Kinsey), Bryan Batt (Salvatore 'Sal' Romano), Ben Feldman (Michael Ginsberg), Jay R. Ferguson (Stan Rizzo), Jared Harris (Lane Pryce), Maggie Siff (Rachel Katz, née Menken), Christopher Stanley (Henry Francis), Alison Brie (Gertrude 'Trudy' Campbell, née Vogel) et.al.

Teleplays:

Matthew Weiner, Andre Jacquemetton & Maria Jacquemetton, Chris Provenzano, Tom Palmer, Lisa Albert, Semi Chellas, Carly Wray, Erin Levy et. al.

Directors:

Matthew Weiner, Lesli Linka Glatter, Phil Abraham, Scott Hornbacher, Michael Uppendahl, Jennifer Getzinger, Barbet Schroeder, Alan Taylor, Tim Hunter et. al.

Acknowledgements

All books are the result of conversations held with others, sometimes leading merely to a single reference, sometimes offering substantial critical comments that help shape the argument. I am greatly indebted to Martin Jaeggy for having insisted that I write a book on *Mad Men* when diaphanes launched their series of slim volumes on TV shows. The book follows the conceptual design of the original series, including the five short scenic impressions of key episodes at the end, even while it is the last, itself marking the end of an era. I am also grateful to Isabel Gil, who kept telling me that, given my obsession with 1950s American culture, *Mad Men* was the show I needed to watch. As I am grateful to Johannes Binotto, who was so committed to introducing me to *Mad Men* that he loaded the entire first season onto my iPhone (and whose comments on what I subsequently wrote were always encouraging). I had told him that I was about to embark on a trip to Burma with my older sister, Susan, who proceeded to watch the show as well on my iPhone, and, during the weeks we traveled together, became my first interlocutor. Part of the charm of this show, as is the case in so many of the great classic novels, is its invitation for self-projection. In our case, given that my sister and I are roughly the age of the Draper children, we were quick to discover family resemblances. Although we grew up in Munich, Bavaria (and not Ossining, New York), Betty Draper's sad boredom along with her dignified elegance was as uncannily familiar as was the deceptively persuasive charisma of Don Draper. Watching

the slow but sure decline of this marriage led to many discussions between my sister and myself about our own parents and what had become of their astonishing post-war optimism. I discovered in Matthew Weiner's time travel a way to ask myself how my own generation became what it did, given the historical moment that so significantly shaped our youth.

My gratitude, however, also goes to all those who helped my while I was researching and writing this book, first and foremost Daniela Janser, whose fine-tuned critical eye forced me repeatedly to rethink the argument of my book. I want also to thank Gesine Krüger for her thoughtful comments along the way. Much thanks also goes to Hannah Schoch, Sabin Jeanmaire and Raffael Hirt for their help with the copy-editing. And last but very much not least, I am deeply indebted to my publisher, Michael Heitz, who made the project possible in the first place.